C000215119

Contents

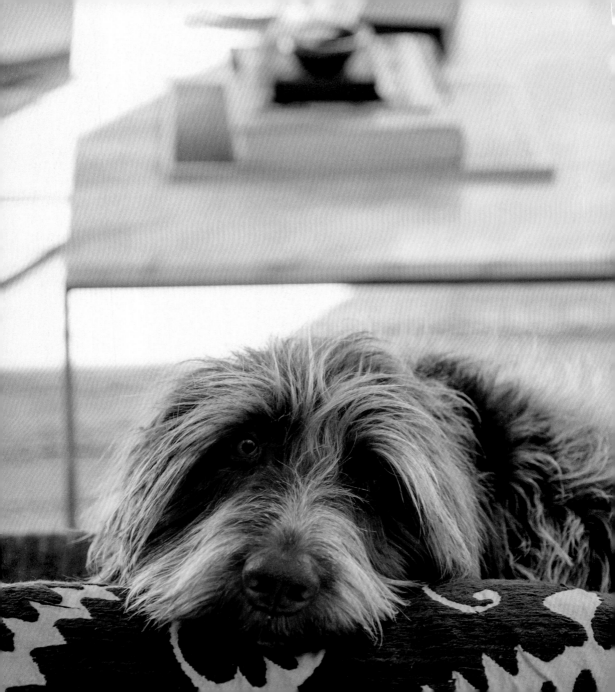

Introduction

We have worked together for many years, travelling the world styling and shooting amazing homes, capturing glamorous lifestyles for magazines and campaigns, but we always found it more interesting when we caught a wagging tail or a pricked-up ear in the picture. This became the inspiration for *Dogs At Home*.

Talking to their owners, we found that the dogs became a catalyst for conversation; we discovered more about the person and their lives in the relaxed and convivial atmosphere that a dog instantly brings into a room than if us humans were left on our own. This common love of dogs opened up a conversation, an intimacy that would not have otherwise occurred.

In the book there are some well-known people, and some well-known dogs, but we also found some unknown people and ordinary dogs with equally special stories. There are modern homes, a stately home, tiny apartments and a garden full of goats with two lurchers for companions. We met journalists, designers, antiques dealers, florists and retailers. We feature wire-haired dachshunds, Great Danes, terriers, poodles, French bulldogs and many mongrels. There are countless rescue dogs and even a Westchester Dog Show champion. After some visits we wanted to cry from the stories of the rescue dogs' journeys to their new owners, after others we were in hysterics at the tales of many of the dogs and their tricks.

All the photography captures that sense of home that only a dog can bring into a house. They are strong, beautiful and evocative images, demonstrating the power of that unique relationship between us humans and our beloved pets.

Marianne Cotterill — *stylist*
James Merrell — *photographer*

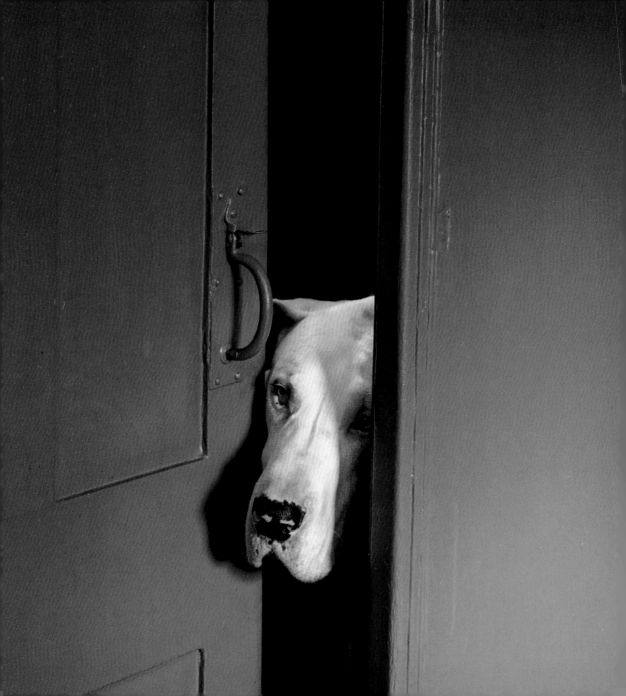

Quinn Toby Mimi and Alex

01

Treading down an uneven cobbled pathway in the centre of Rye, East Sussex, the descent is almost vertical. Halfway down on the right is a large black doorway on the side of a dark brick building with an overhanging star. This is a fourteenth-century monastery, now taken over by Alex Macarthur, antiques dealer and interior designer, and her three dogs. Pressing the thumb-worn bell induces a booming bark and a chorus of yaps. The boom belongs to Quinn, the harlequin Great Dane; the chorus is Toby the French bulldog, and Mimi, a Jack Russell terrier. *Continued on page 219...*

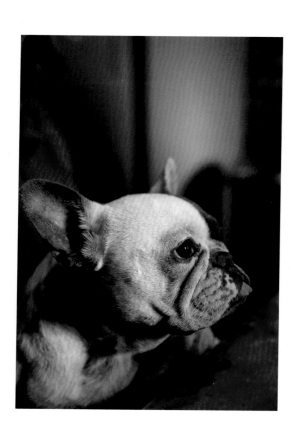

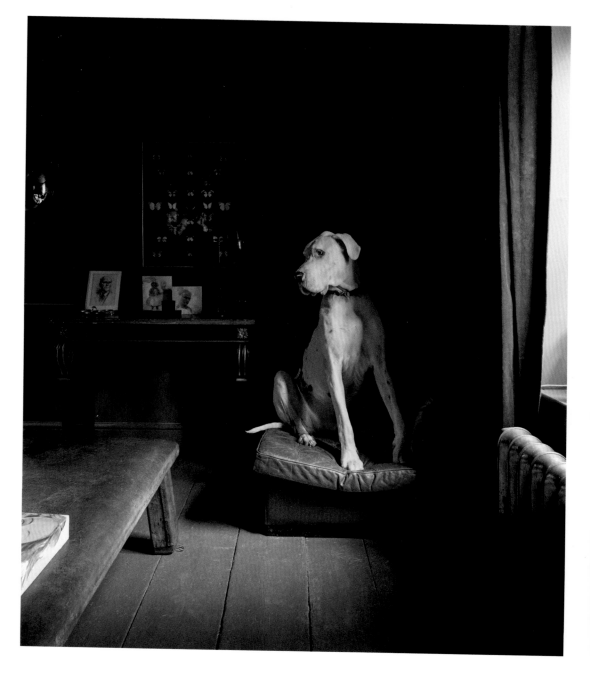

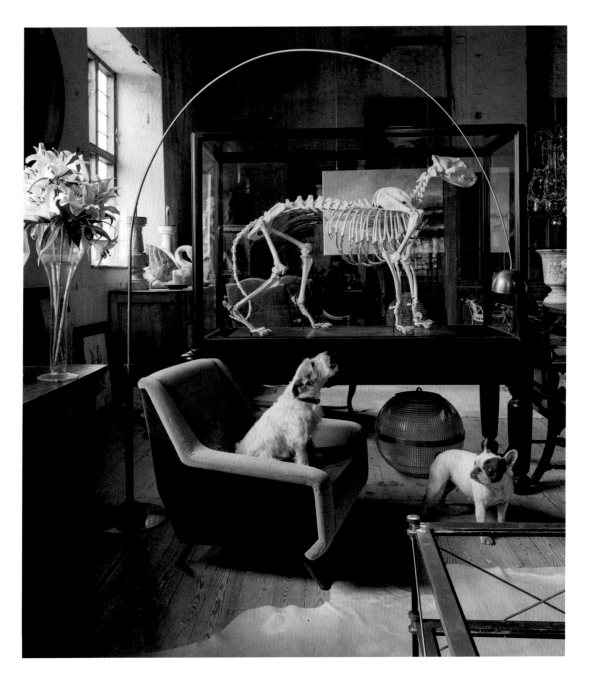

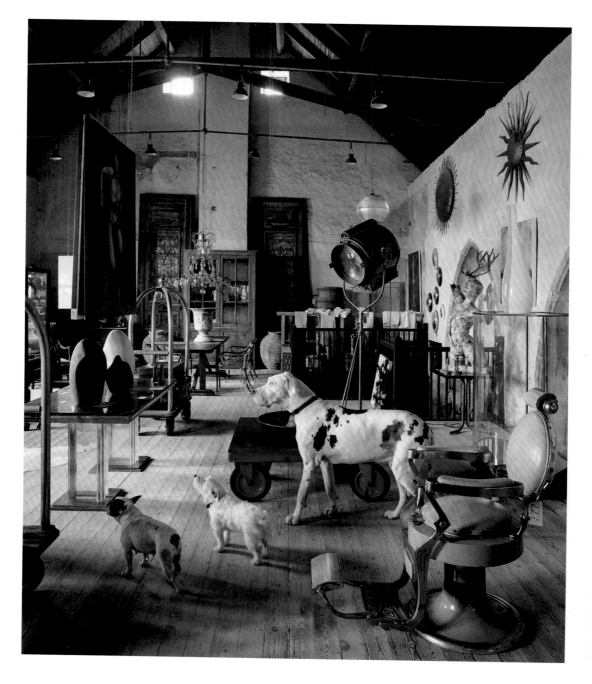

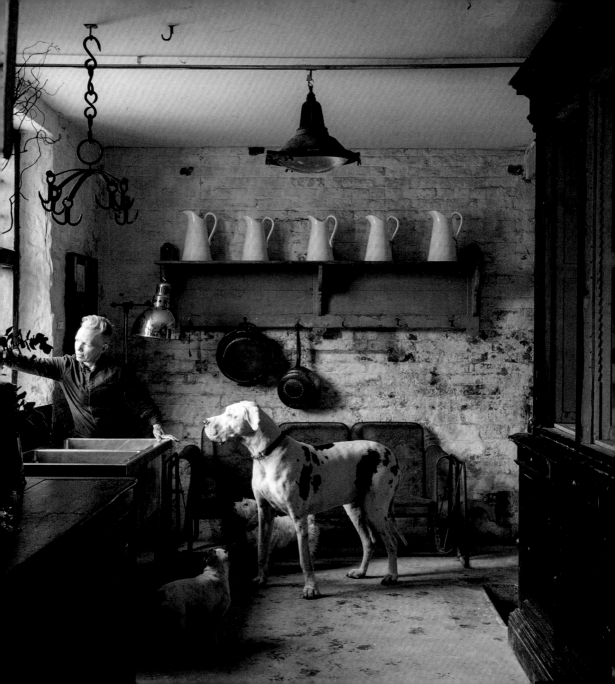

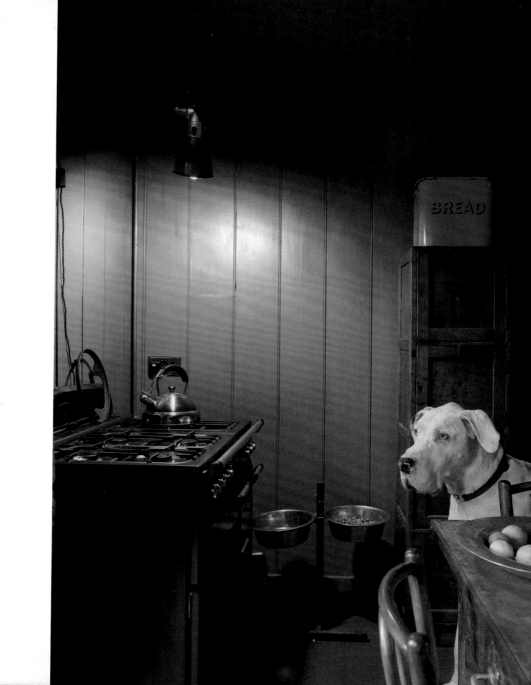

Bean

and

Carol

Bean is one of the tiniest dogs you will ever meet. She weighs a mere three pounds and belongs to Carol Prisant, author of *Dog House: A Love Story* and American editor of *The World of Interiors* magazine. Bean is a Mi-Ki, and the size of a shoe. She's too small for the New York sidewalks and its many hazards, so this tiny dog cruises in a bag until she hits the park. Bean is confident but mellow, always sociable and loves being admired. *Continued on page 220...*

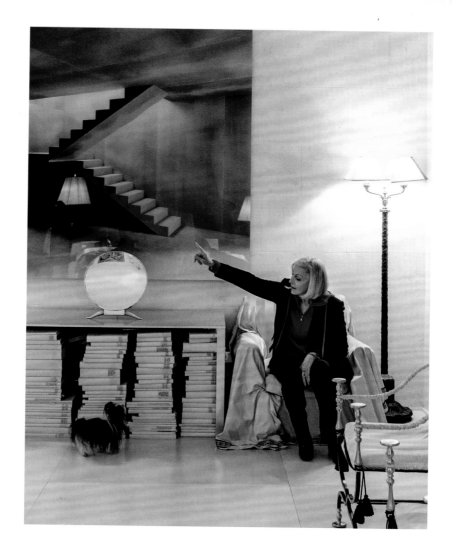

Charlie

Prune

Yolanda

Matt

and

Clara

03

In the middle of a meadow in Sullivan County in New York State stands the country house to which Yolanda Edwards, Matt Hranek and their daughter, Clara, escape at weekends with their two dogs, Charlie, a Patterdale terrier, and Prune, a Jack Russell. Looking out of the huge window that forms the entire front of the house gives the sensation of being suspended in mid-air, with the fields and forest below stretching off into the far distance. It's doggy Nirvana for Charlie and Prune. They can ruminate on the world below from inside the house and scamper around outside to assuage their hunting instincts.
Continued on page 221...

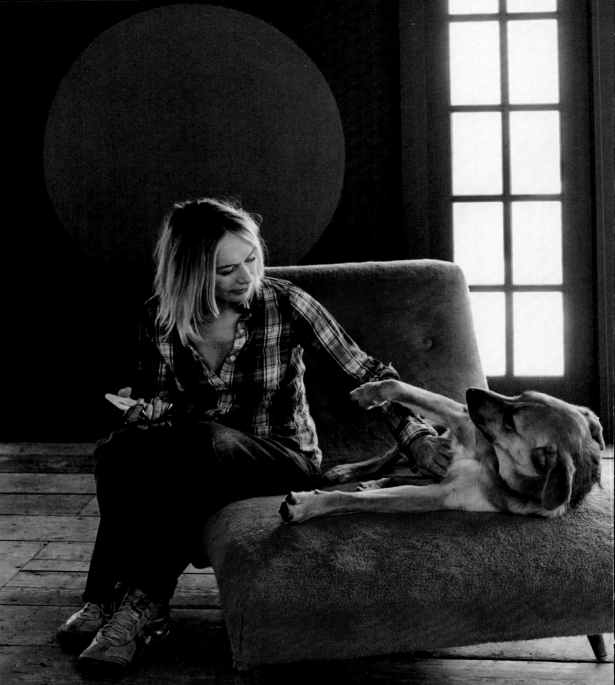

Ciccia Thurber

and

Ann Marie

04

Ann Marie Gardner shares her house on a hill in Germantown, New York State, with Thurber, a Pyrenean Mountain mixed with something unidentified (possibly some sort of hunting dog), and Ciccia, whose temperament is as feisty as Thurber's is Zen-like. Thurber, a native of Georgia, is named after James Thurber, one of Ann Marie's favourite authors. He's referred to as 'the Buddha' by those who know him. Ciccia is from the Dominican Republic and Ann Marie's friend calls her 'Coochie Mama' because when she walks, her hips sway and her tail curls. Ann Marie says Ciccia wants what she wants when she wants it. *Continued on page 222...*

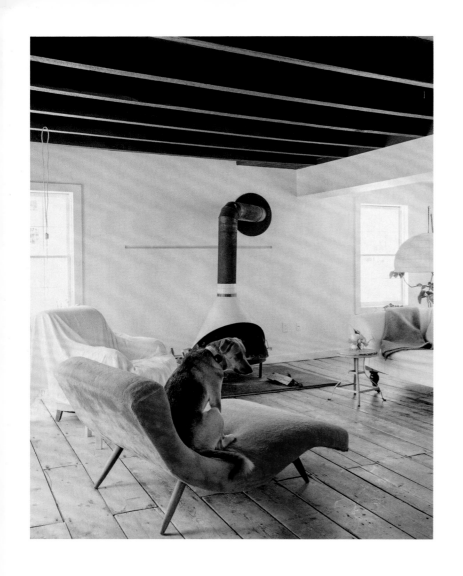

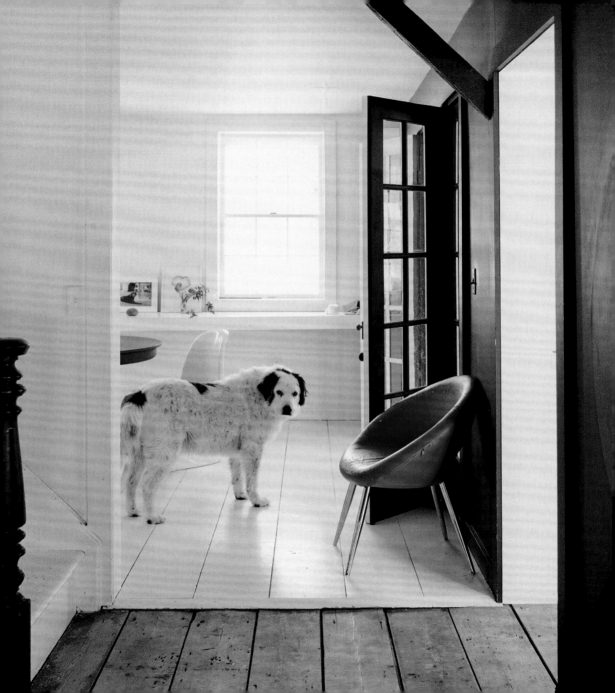

Darryl

Caroline
and

Michael

05

Caroline and Michael Ventura's first encounter with a wire-haired Pointing Griffon was at a 'Meet the Breeds' (and breeders) event at NYC's Javits Center. Michael had never had a pet; Caroline grew up with lots. A year later, they welcomed Darryl to their temporary home, a small studio flat in Times Square. When he was one, they moved to their newly renovated West Village building. Darryl enjoys the huge space and outside terrace. He's welcome in every part of the four-storey building, which is both the Venturas' home and their workplace. *Continued on page 223...*

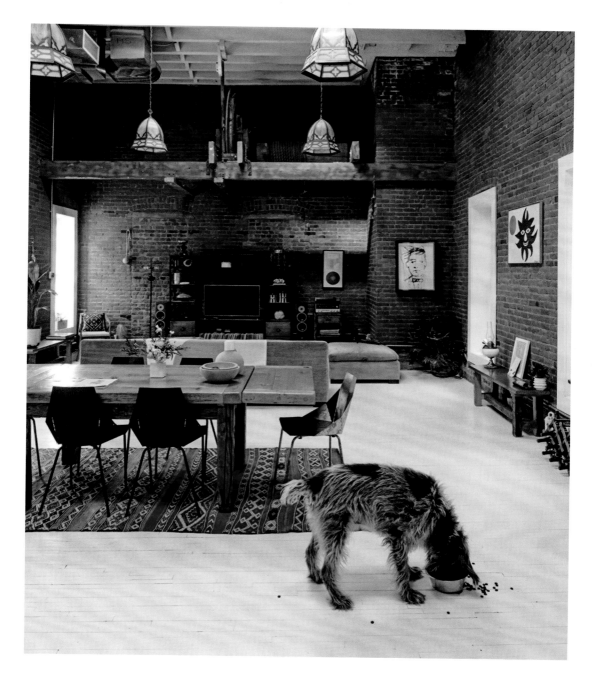

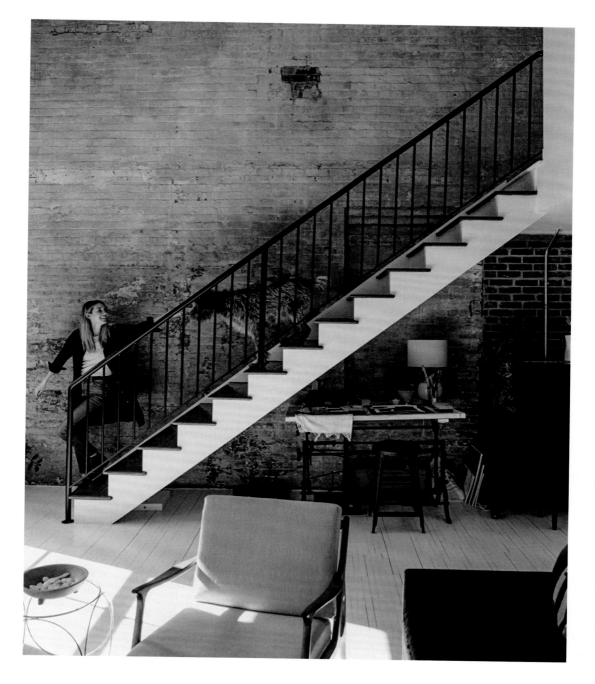

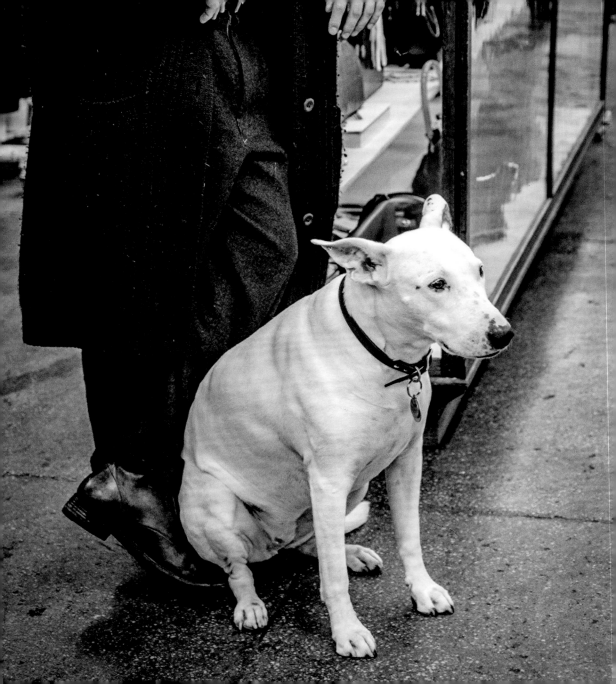

Dumbo

Moon

and

Heyja

Every day, an English bull terrier called Dumbo takes a twenty-minute walk to Dear Rivington, a very cool store in NYC, with her owner, Moon Rhee. Her name is Dumbo because she used to live in Dumbo, Brooklyn (she has never been to England). She hates walking in the rain, but doesn't mind the snow. Moon has customised some vintage kids' sweatshirts for her to wear to keep the cold out. When they reach the store, Dumbo says hi to the staff, then flops into her faux-fur dog bed, under a yellow fleecy blanket. *Continued on page 225...*

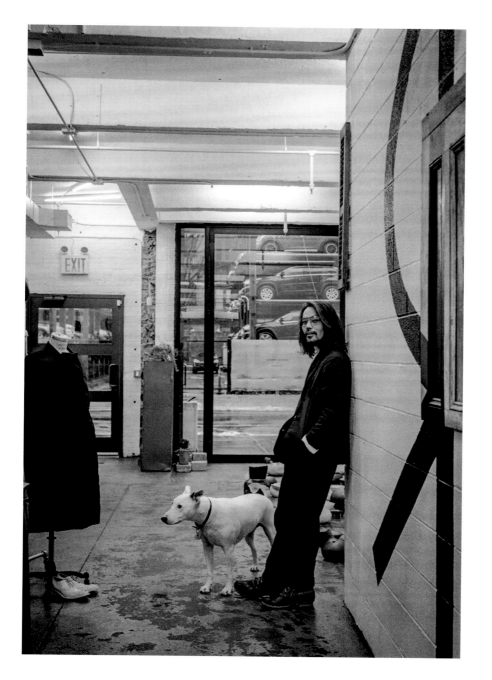

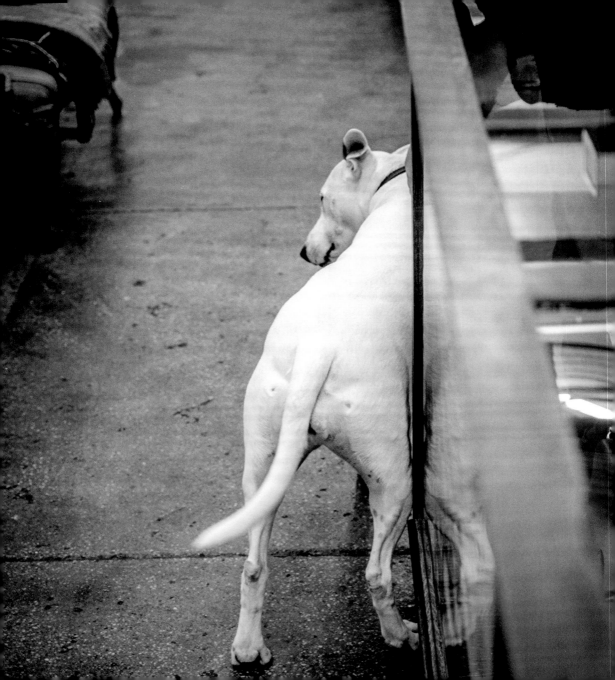

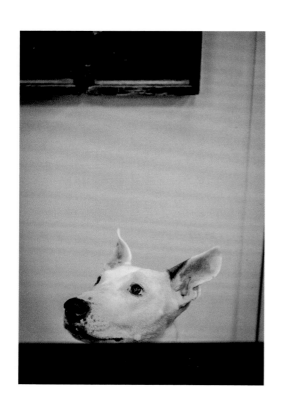
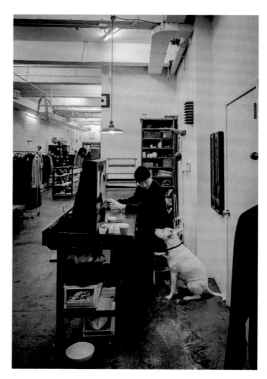

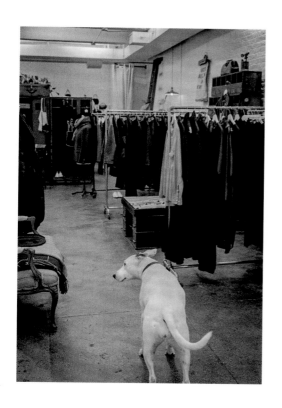
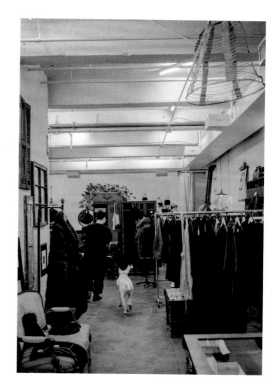

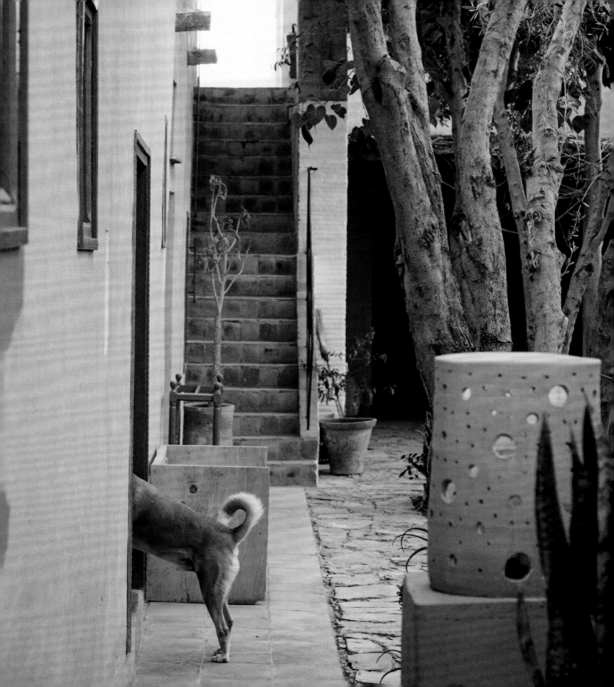

Idir Max Lina Linda Diablo and Ollivier

07

Looking across to the distant snow-capped Atlas Mountains stands Dar al Hossoun, a light and airy eco-friendly Moroccan riad where a curious assortment of dogs enjoy a blissful existence with Ollivier Verra, the man from Provence with whom they were all destined to live. They are Idir, a white Maltese Bichon Frise cross, a temporary guest who became a fixture; bushy-tailed Max, who walked many dusty miles in his determination to be with Ollivier; tan, three-legged Lina, discarded for being too noisy; tiny wild-haired Linda, found abandoned in a box by the roadside; and black-and-tan Diablo, who was left at Ollivier's door. He found each of them literally irresistible. *Continued on page 226...*

Continued on page 226...

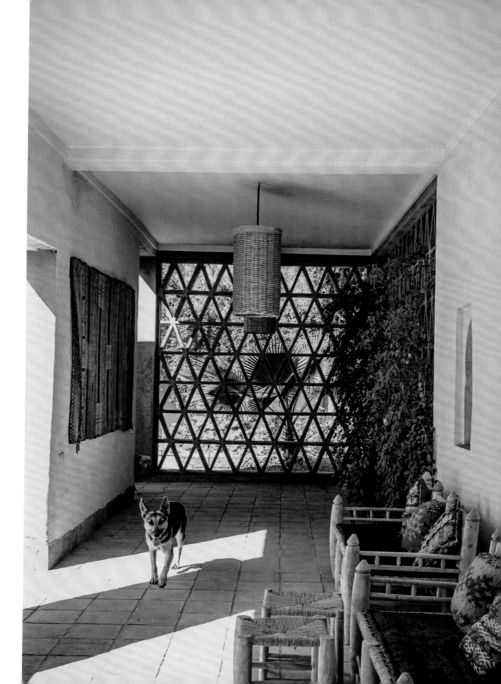

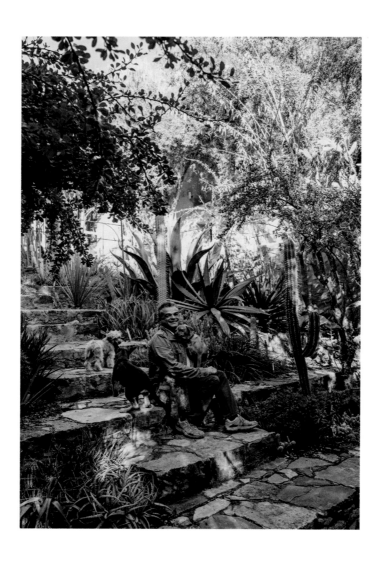

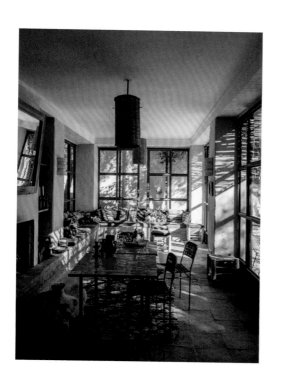
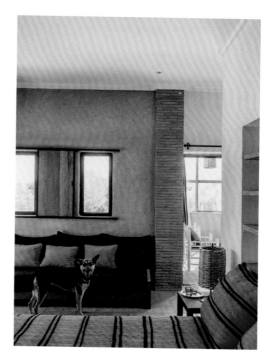

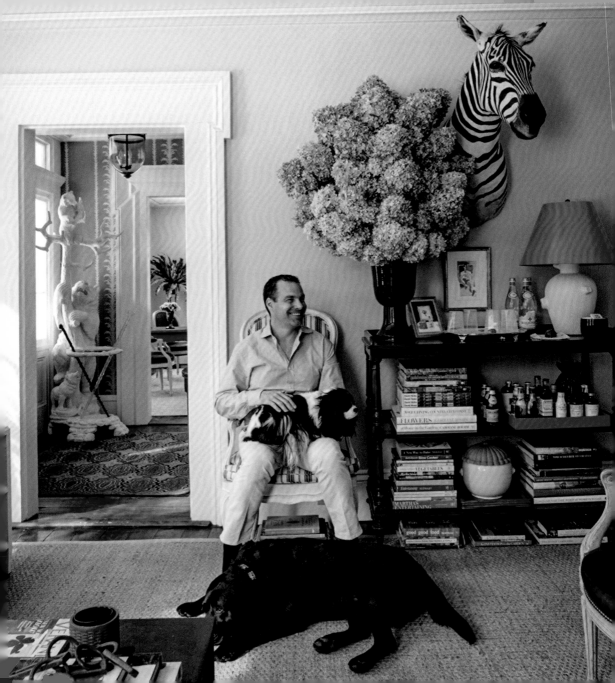

Fanny

Lyon

and

Christopher

08

Every weekend, Fanny and Lyon leave an apartment in NYC for Clove Brook Farm in Millbrook. Their owner, Christopher Spitzmiller, drives them there; they enjoy the ride. They both have very different personalities. Fanny is a confident, sassy Cavalier King Charles spaniel, a breed long admired by Christopher. She has no fear, and is both the smallest and bravest dog Christopher has ever known. Lyon is a friendly Labrador, sometimes sheepish, but very handsome — the looker of the Spitzmiller household, Christopher insists. He describes Fanny and Lyon as two of the most sociable, devoted dogs he's ever had. *Continued on page 227...*

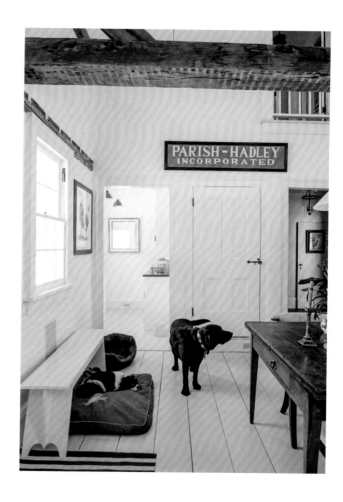

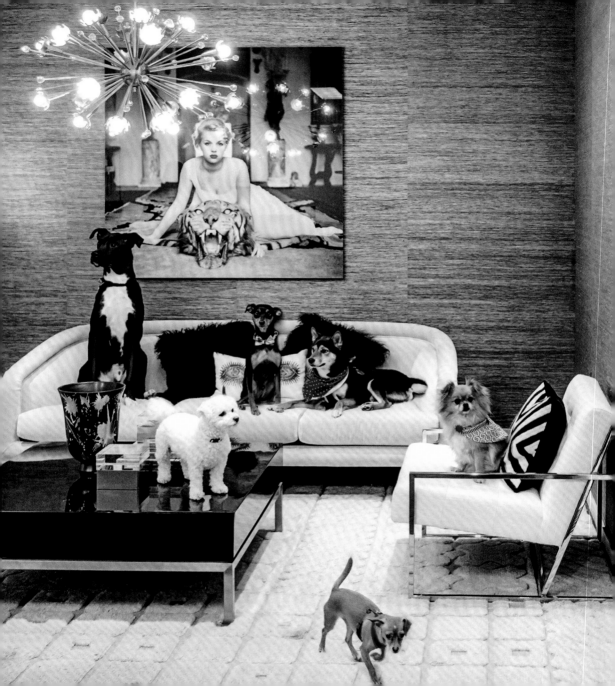

FoxyLady

and Other Friends

Jonathan

and Simon

09

FoxyLady, described as 'an alluring mix of breeds', lives with Jonathan Adler and Simon Doonan. They're not sure how old she is: 'A lady never tells, especially a lady who is rescued and isn't quite sure.' She goes to work most days with Jonathan, a self-taught potter who now runs a global business. Work is an entire floor of a building in Soho, NYC, populated by a fluctuating number of dogs — all essential, Jonathan stresses, to a happy, successful workplace. His office reflects the modern, chic, glamorous style he's renowned for. It could be a room from a 1960s James Bond movie, with FoxyLady replacing Blofeld's Persian cat. *Continued on page 228...*

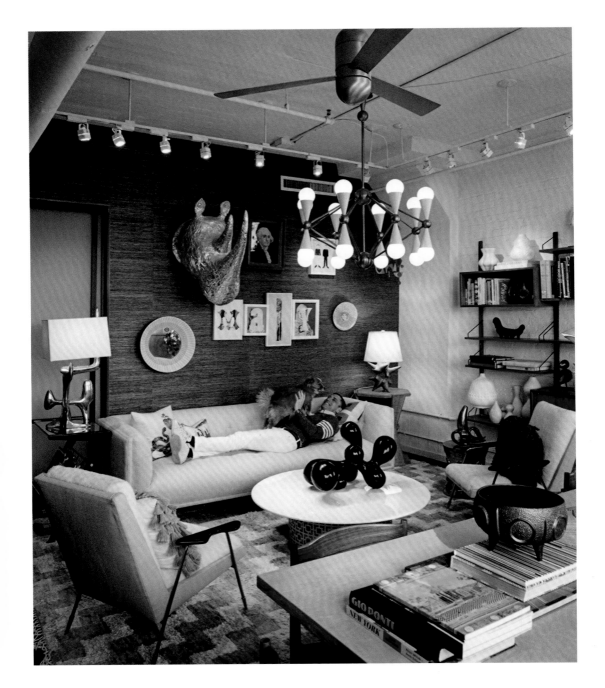

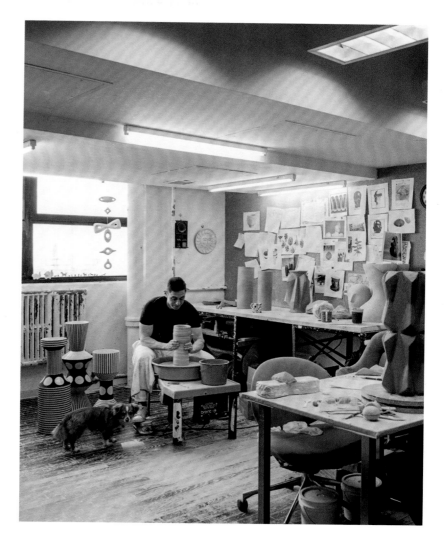

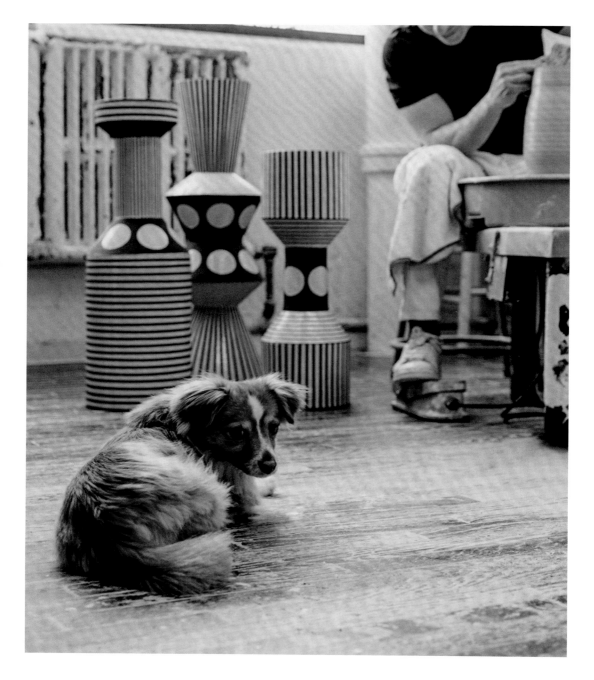

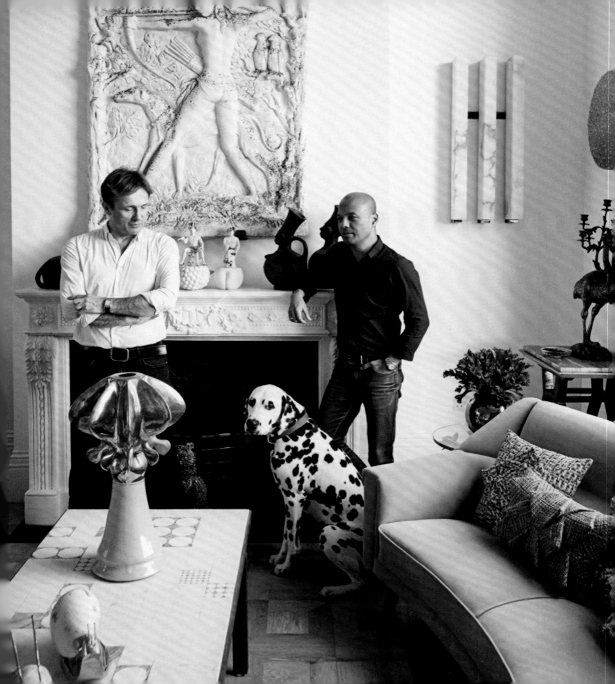

Gaspard Michel

and

Hassan

10

Gaspard is a handsome Dalmatian with an immaculate coat.
He's aware of his good looks and stays as still as a statue
if he thinks a photograph is on the cards. In the Regency
period of the early nineteenth century, it was a status symbol
to have a Dalmatian trotting alongside your horse-drawn
carriage — they were known as the 'Spotted Coach Dogs'. Michel
and Hassan, Gaspard's owners, agree that they just can't see
him trotting alongside a carriage. He'd be more likely to jump
inside, get comfortable with a blanket and watch the world
go by. 'He is the ultimate aristocrat,' says Michel.
Continued on page 229...

 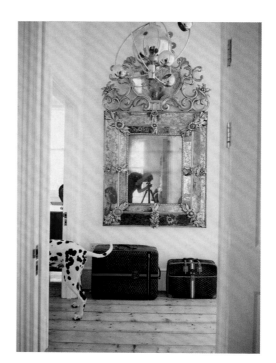

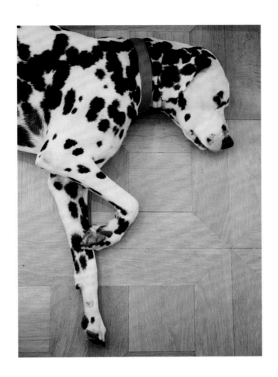

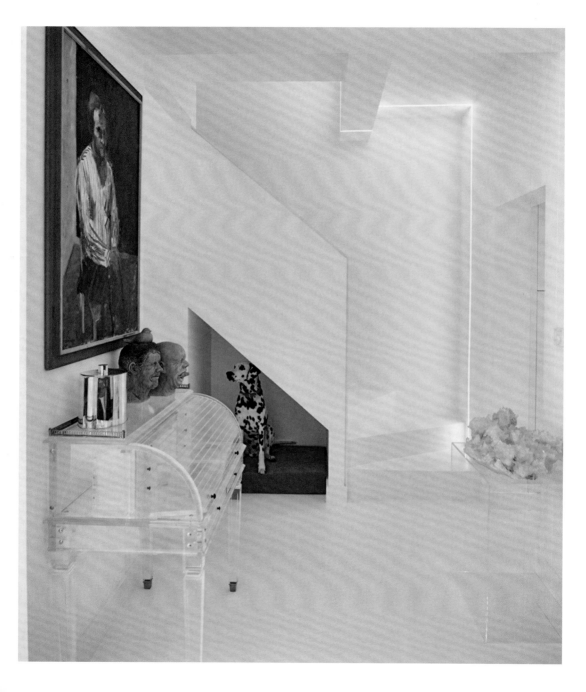

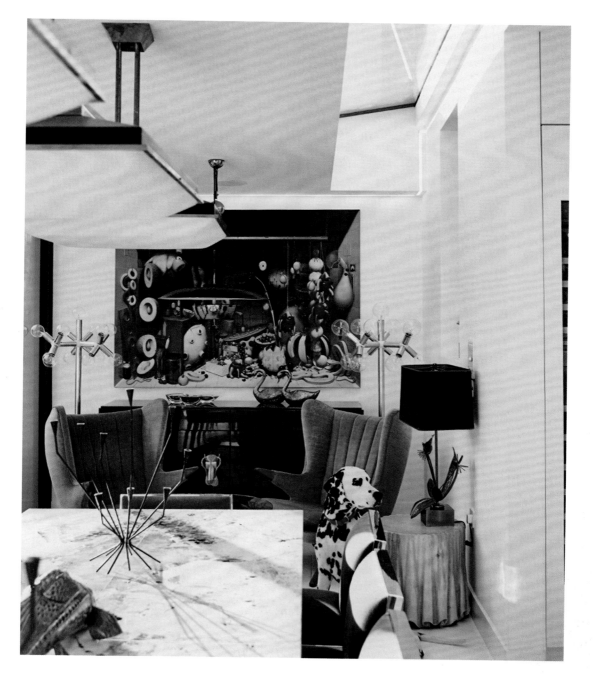

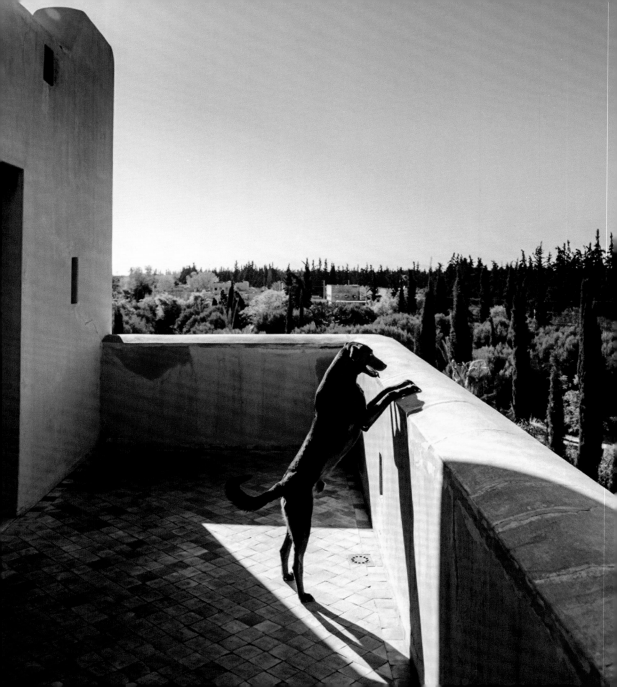

Ghita and Max Karl

Ghita and Max live with their owner, Karl Morcher, in Taroudant, the former capital of Morocco. Ghita and Max are both street dogs, brought to Karl by his gardener. Ghita arrived first, aged about eighteen months. She was in a poor state, having been badly mistreated. It took her a while to settle — she was sweet and gentle, but apprehensive around people. Max came to Karl when he was about three months; he is relaxed, mischievous and playful, not having experienced the same cruelty as Ghita. When Max arrived, Ghita took care of him, mothering him, but now he acts like a naughty adolescent with her.
Continued on page 230...

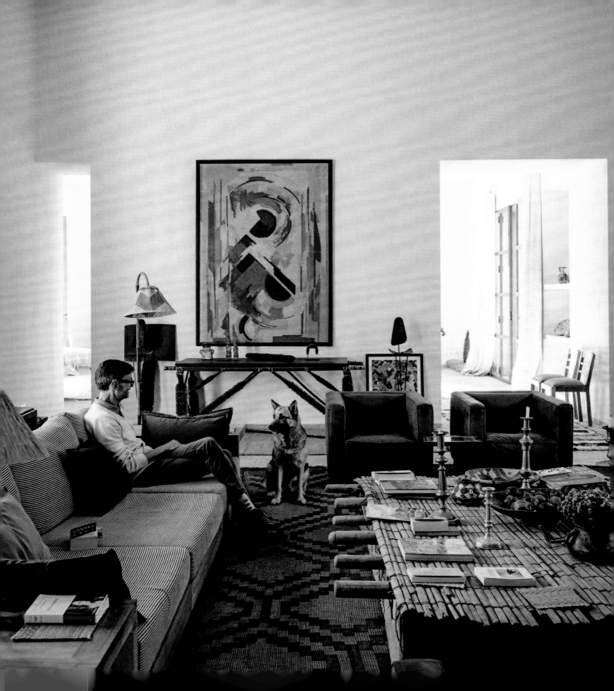

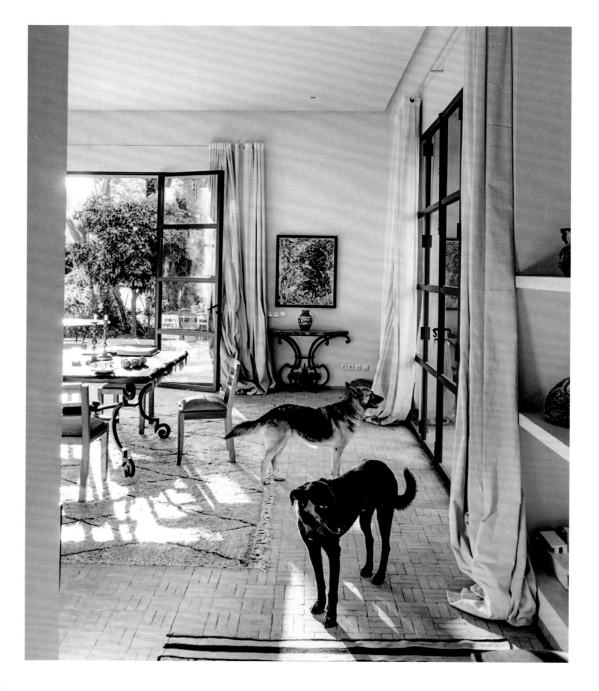

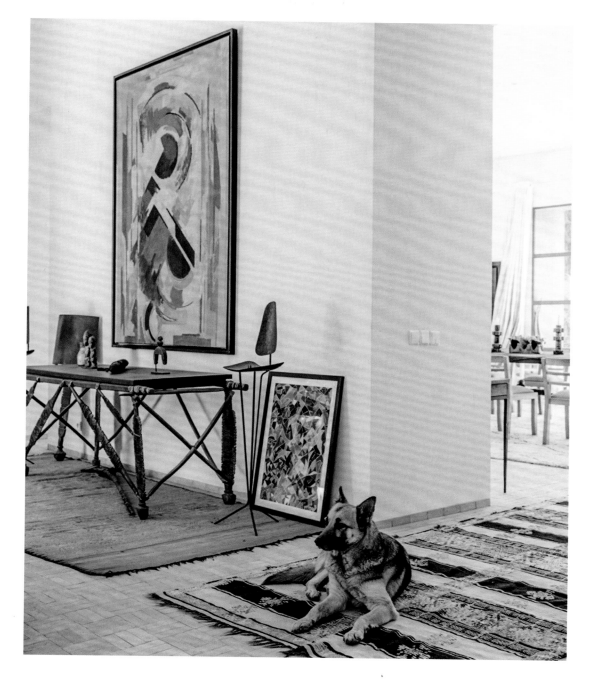

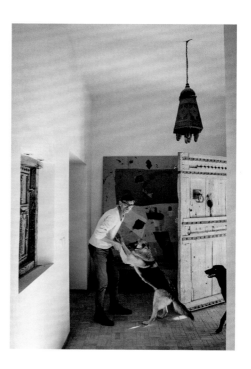

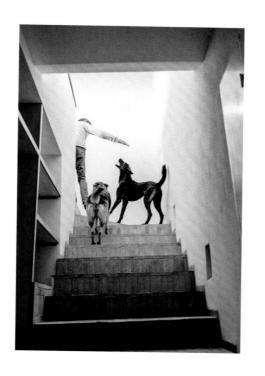

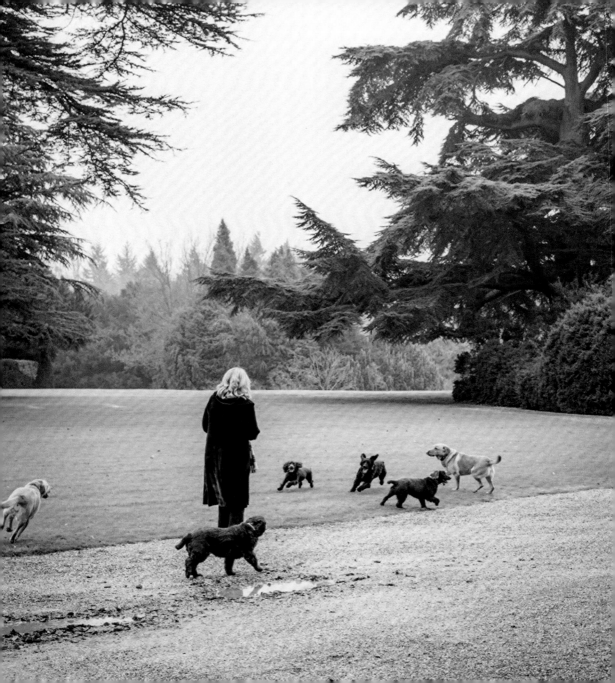

Bella Winston

Clemmie Rosie

Evie Alfie

Ted Fiona

and George

12

Walking into the library of Highclere Castle is a feast for the senses, the vast room redolent with the perfume of swollen hyacinths, leather-bound books and beeswax polish. Bella, the Labrador, comes bounding in with Lady Fiona Carnarvon and flops down on the rug next to the sofa, grinning widely, happy to see everybody. Lady Carnarvon apologises for being slightly late (one of the dogs came via the bins), and introduces Bella as her old friend and a lovely person. Highclere Castle is best known as the real Downton Abbey, and it is Bella who features in the opening sequence, strutting joyfully along in the grass. *Continued on page 231...*

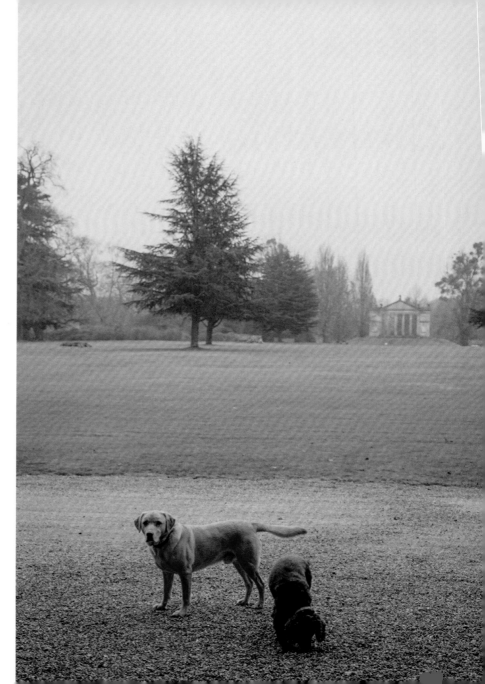

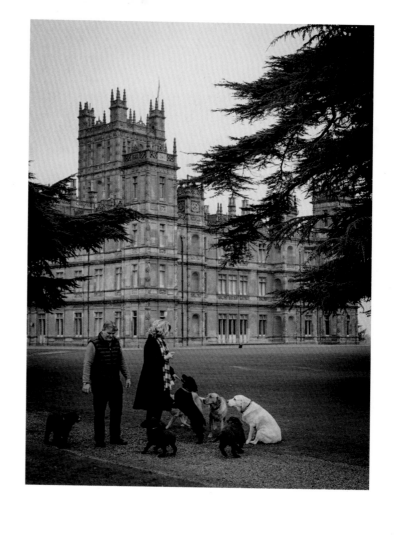

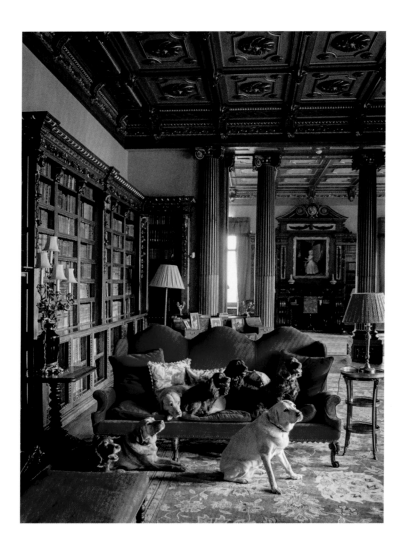

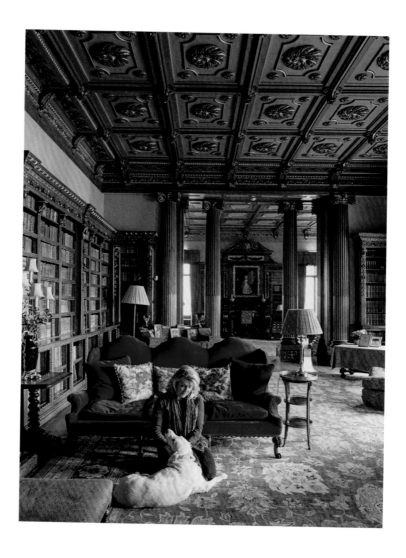

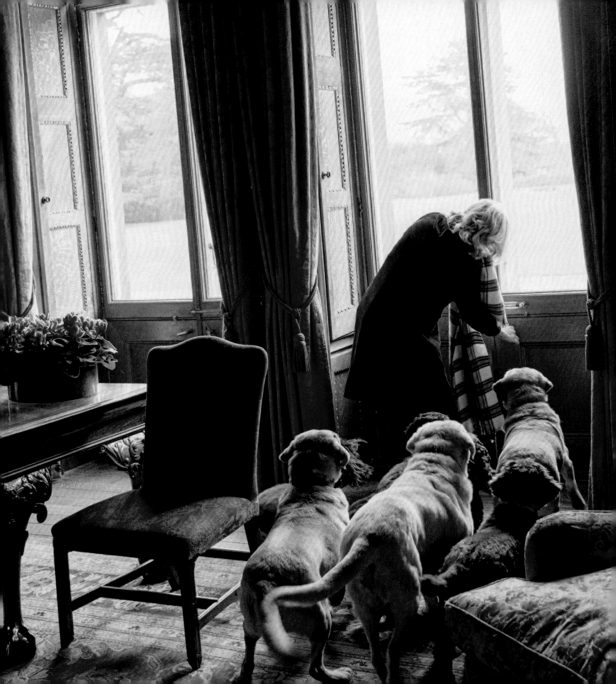

Oxy

Gen

JC

and

George

13

JC Garcia-Lavin, an artist and stylist, and George Fesser, realtor, are natives of Miami who now live in Manhattan with their two dogs, Oxy and Gen. Both dogs were five months old when they came to JC and George, but their stories are very different. Oxy, a Welsh terrier, arrived first, after careful research to track down a reputable breeder. Black-and-white Gen, on the other hand, is of indeterminate breed and was spotted by George in a truck parked by a pet sanctuary, full to the rafters with cages containing dogs rescued from the aftermath of Hurricane Harvey. Both dogs are as important to JC and George as — oxygen. *Continued on page 232...*

Loki

Zephyr

Catherine

and

Julius

14

Loki the lurcher is from Preloved, a charity that rehomes dogs. His new owner, Catherine, drove for three hours to meet him. He was scruffy, with runny eyes, skinny and exhausted, but Catherine knew instantly that this was a special dog. She paid the previous owner a sum of money and he sped off in his van, while Catherine spoke to ten-month-old Loki and assured him he was to live with her and her son Julius in the Suffolk countryside and be their much-loved pet. It was obvious that he'd been used for hunting, and it took some time to make him realise he was under no pressure to work constantly. Loki now has a son named Zephyr. *Continued on page 233...*

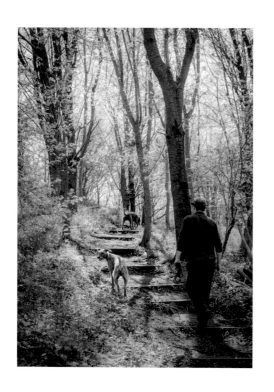

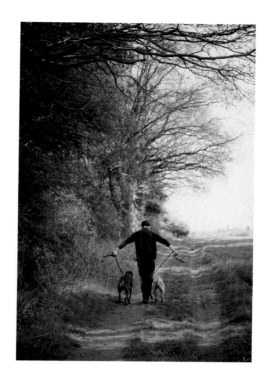

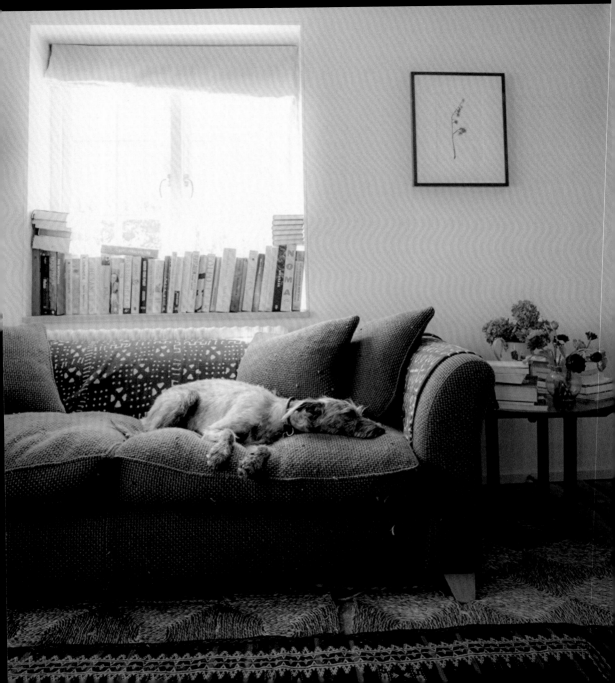

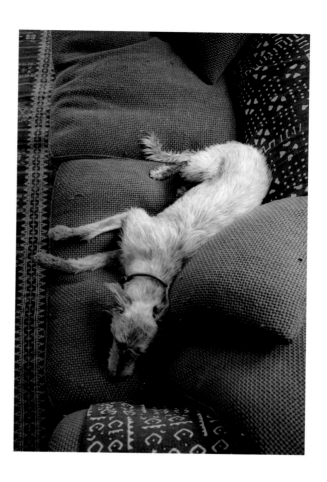

Monty

Bertrand and

Howard

15

Monty lives on Montrose Avenue in north London, with Bertrand Pierson from France, a hotel consultant, and Howard Rombough from Toronto, Canada, a communications director for a luxury hotel group. Monty is a handsome German pointer, known locally as Monty of Montrose, such is his refined, aristocratic demeanour. When Bertrand and Howard first saw Monty in the litter of puppies, they loved the white brushstroke on his head. 'I call it the mark of an angel,' says Bertrand. They gave him a spoonful of champagne when they brought him home, a traditional welcome ritual for new babies, popular in France. *Continued on page 234...*

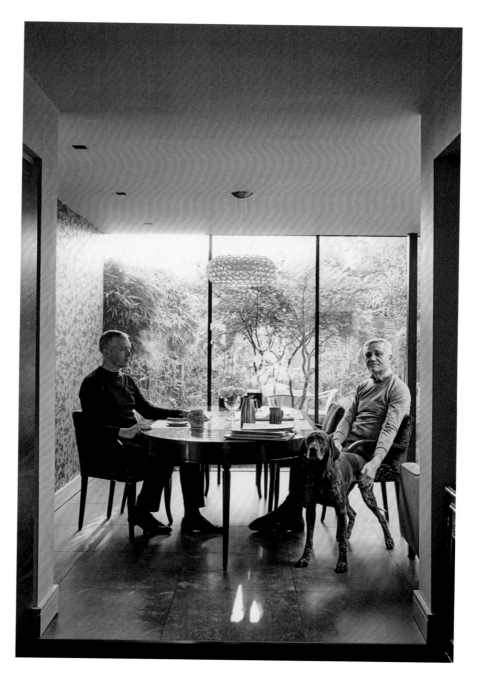

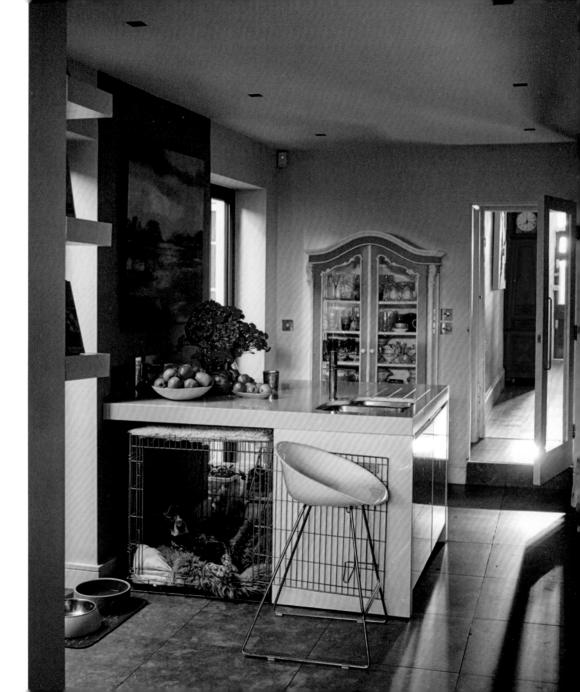

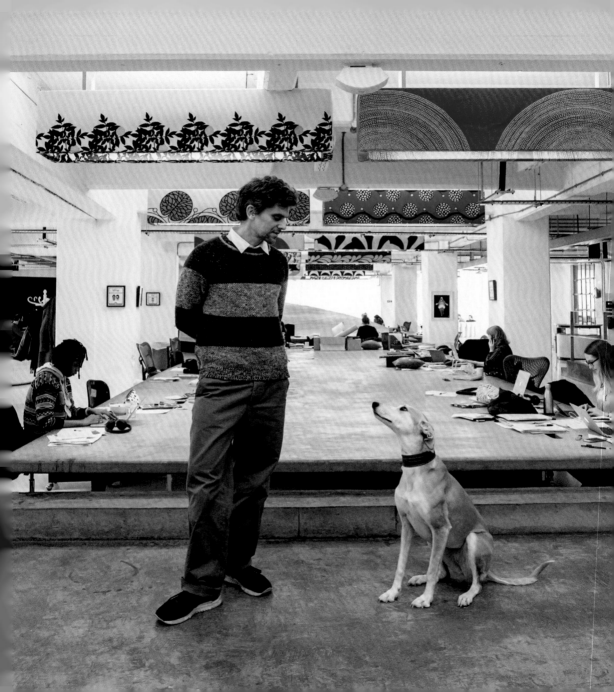

Rocco Bear Hector Bonnie Poppy Lee Claudia Margot Chelsea Larry and Shana

16

Mother is a creative agency with offices in London, New York and Buenos Aires and is the UK's largest independent advertising agency, their philosophy being to make great work, have fun and make a living, in that order. The London office is in Shoreditch, designed by Clive Wilkinson Architects. One of the main features of the space is the huge concrete desk, which can seat the entire Mother staff and any dogs who accompany them. The dogs have their crates, baskets and beds tucked underneath the desk. They are welcomed and enjoyed in this unusual creative workplace. Employees love to come and say hi and spend time with them, often remarking that they are a comforting, cheerful presence in the office. *Continued on page 235...*

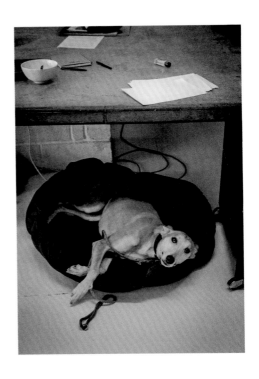

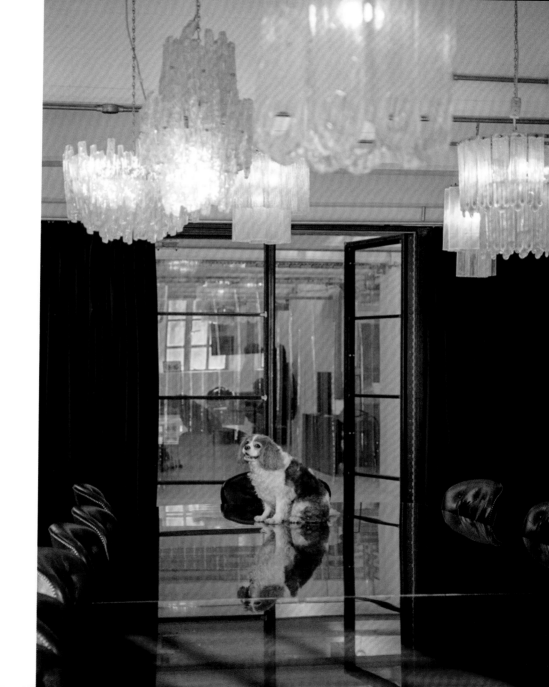

Nat Carla

Rocky

Tita

Simon Carla

and Charles

17

Carla, a.k.a Lady Powell, lives in an Italian 'dog heaven'.
Her five dogs — dachshunds Simon, Nat, another Carla, Tita,
and Rocky, a Belgian Malinois — are with her day and night.
The small ones share her bed, though they regard it as theirs,
and they resent it bitterly when Charles (Lord Powell) joins
them at the weekend. Lady Powell says that, for most of her
life, dogs didn't get a look in because of her husband's career
in central London and in various diplomatic postings overseas;
but the Roman countryside is the perfect environment for them.
Continued on page 236...

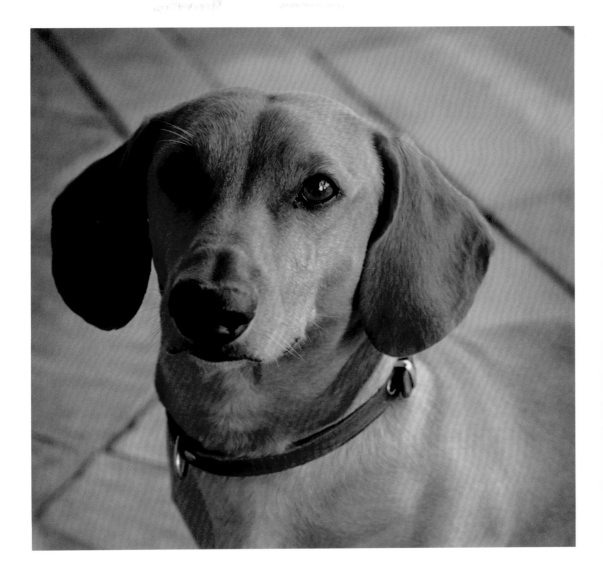

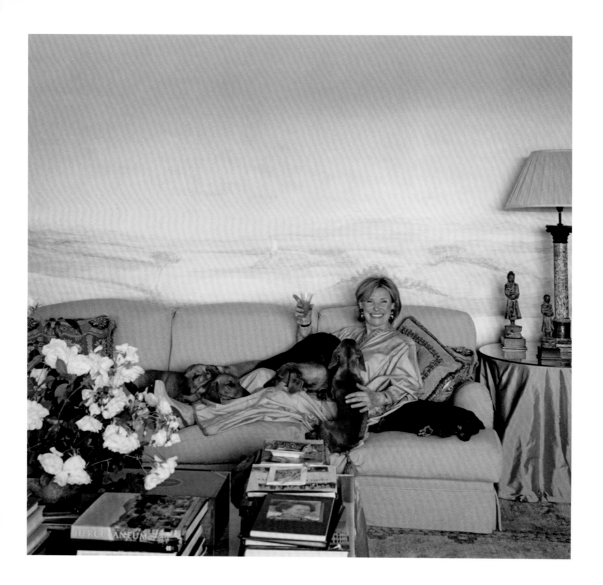

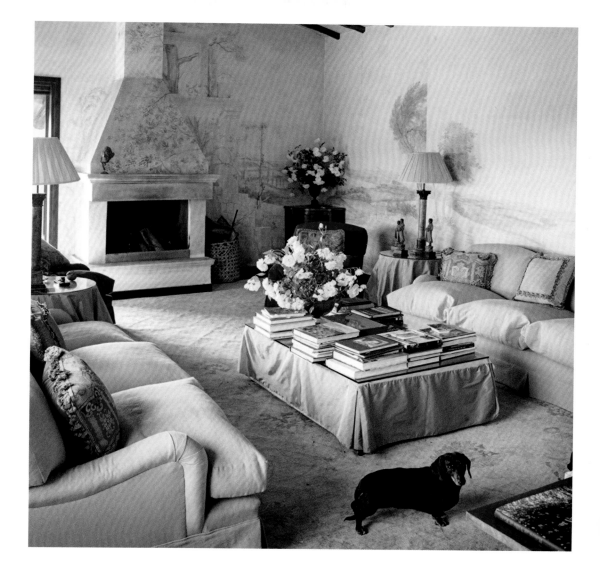

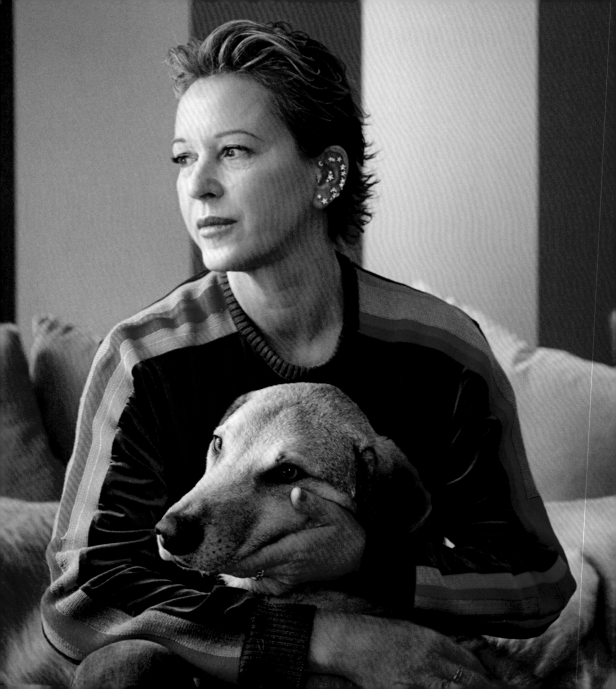

Ronnie Smith
Lenny Ruby
Rita
Tia
and Nikki

18

Nikki Tibbles is one of the UK's most celebrated florists. She lives in Notting Hill, London, with her six amazing rescue dogs — Ronnie, Smith, Lenny, Ruby, Rita and Tia. Nikki's love of dogs began when she was a baby — her parents often used to find her curled up with their two boxer dogs in their beds. Since then, she has had twelve rescue dogs. She is co-founder, with Nadine Kayser, of the global dog charity Wild at Heart Foundation. Their 'Adopt Don't Shop' slogan has been instrumental in finding homes for thousands of dogs, and the foundation works assiduously to make sure the right dog goes to the right person. *Continued on page 237...*

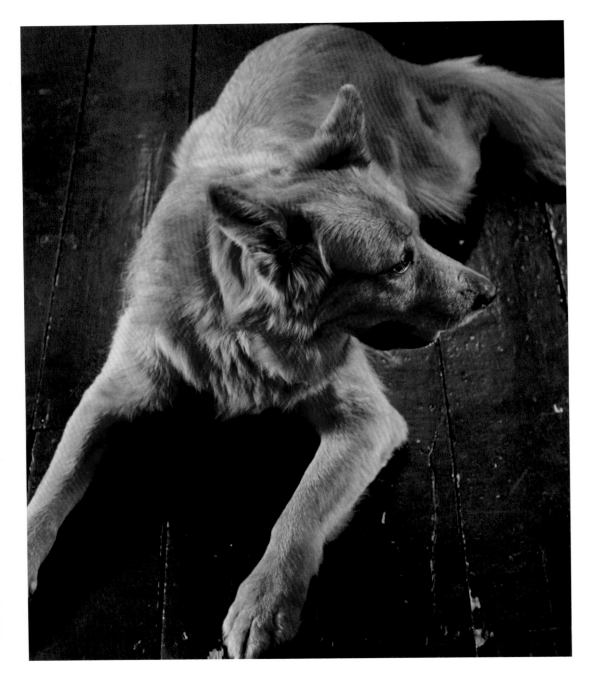

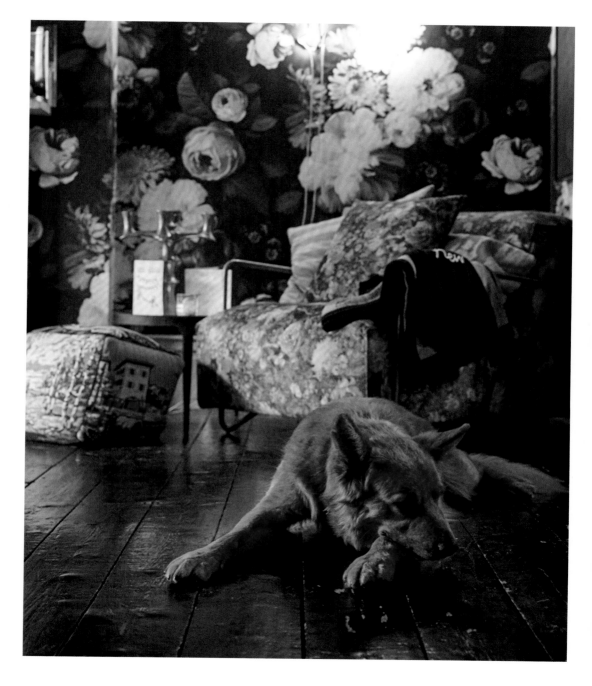

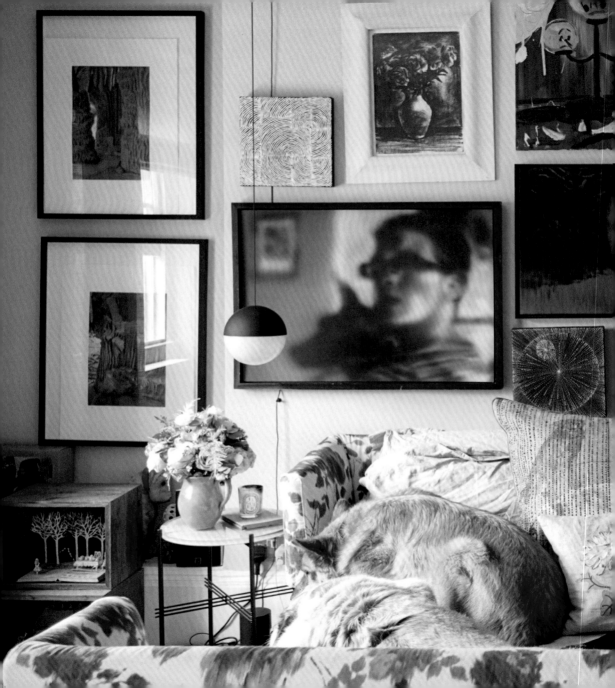

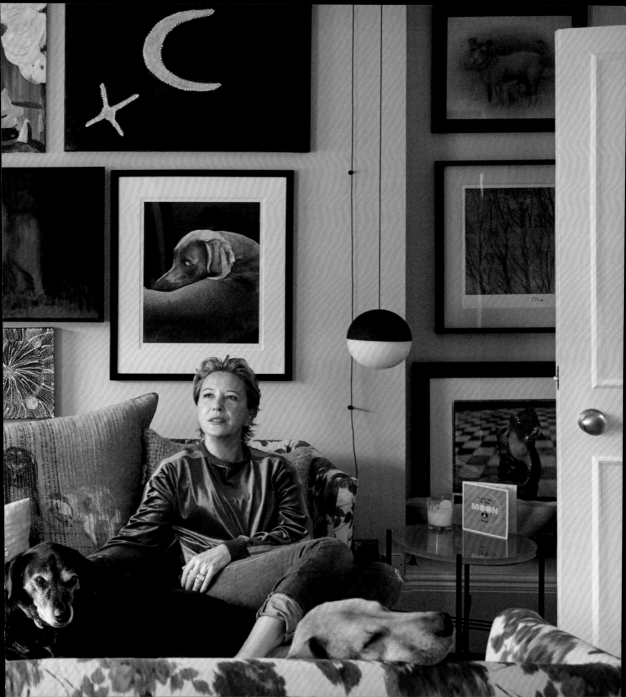

Ollie Victoire Ramdane Noor Adam and Scheherazade

Ollie de Taillac Touhami is a Jack Russell who lives in Paris with her owners, Victoire and Ramdane, and their children Noor, Adam and Scheherazade. She knows everybody in the neighbourhood, from the baker to the newsagent and the regular café staff and customers. Ollie is a little homebody who would rather stay with Victoire's mother, a five-minute stroll away, than go to Victoire's office. She finds it too chaotic and messy; she can never settle, preferring organisation and calm. Victoire always explains to Ollie when there will be any change to her daily routine. She's much more co-operative and less stressed when she knows what's planned. *Continued on page 238...*

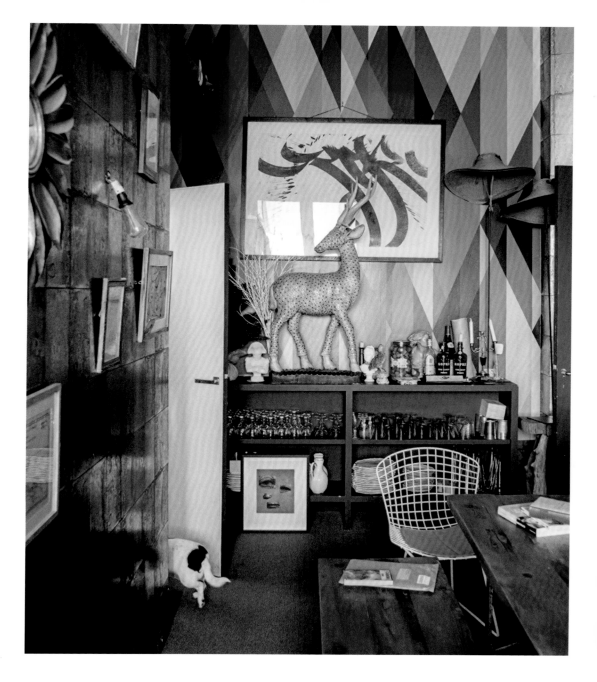

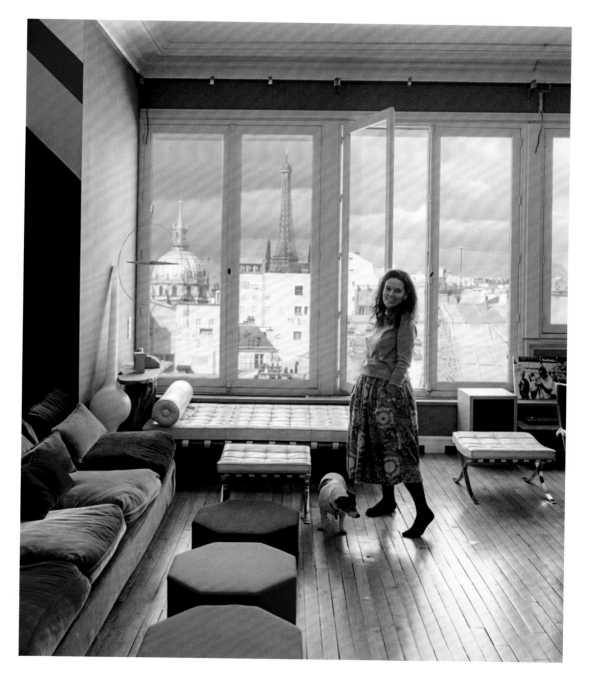

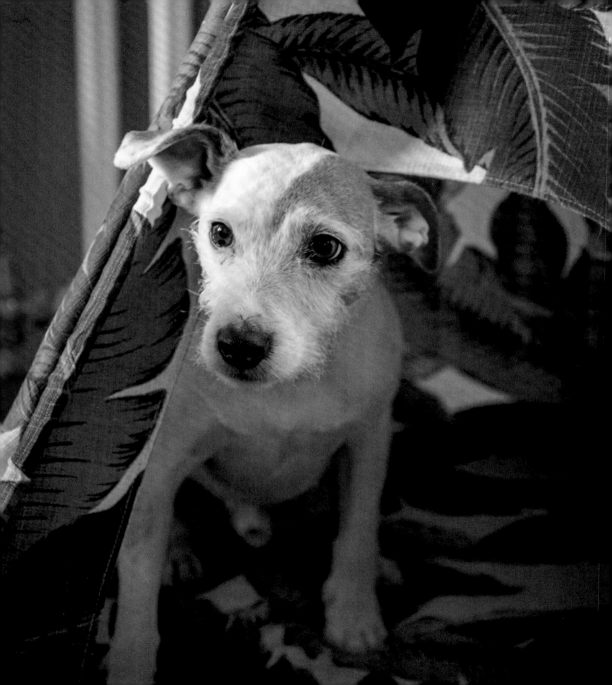

Riley and Fiona

20

Fiona Leahy went out one morning to buy flowers and came back with a dog. Outside the florist was a woman holding a cage with a puppy inside, wrapped in a dirty British Airways blanket. Fiona gave her sixty pounds and returned home with an eight-week-old Parson Russell terrier. Fiona took Riley to the vet the next day to be checked over, only to find that his previous owner had tried to have him euthanised there, saying he had swallowed bleach and that he had a tumour on his neck. The 'tumour' turned out to be knots, stress-related, which disappeared a few days after Riley moved in with Fiona. *Continued on page 239...*

Continued on page 239...

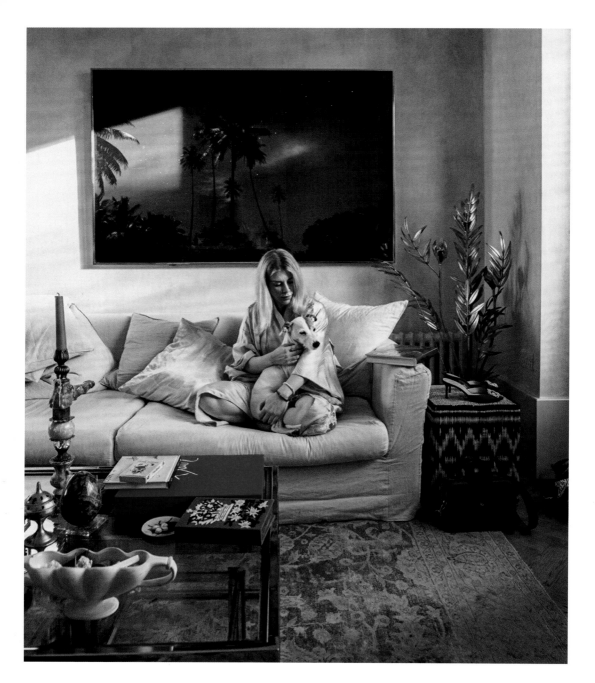

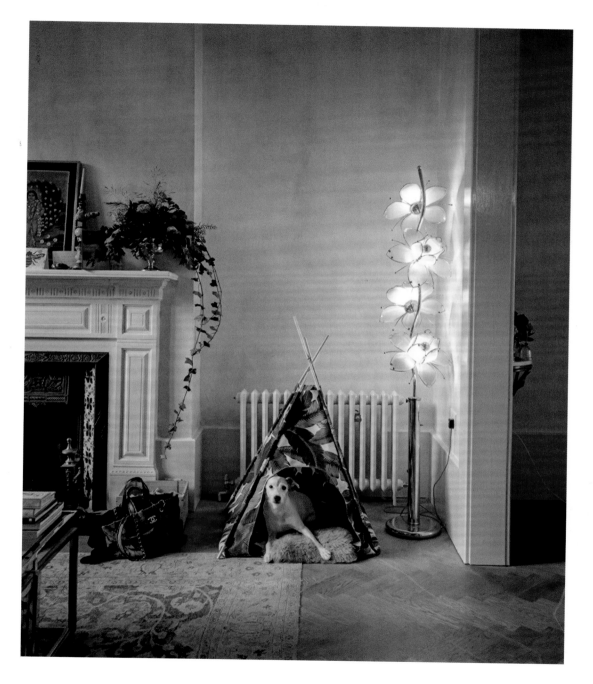

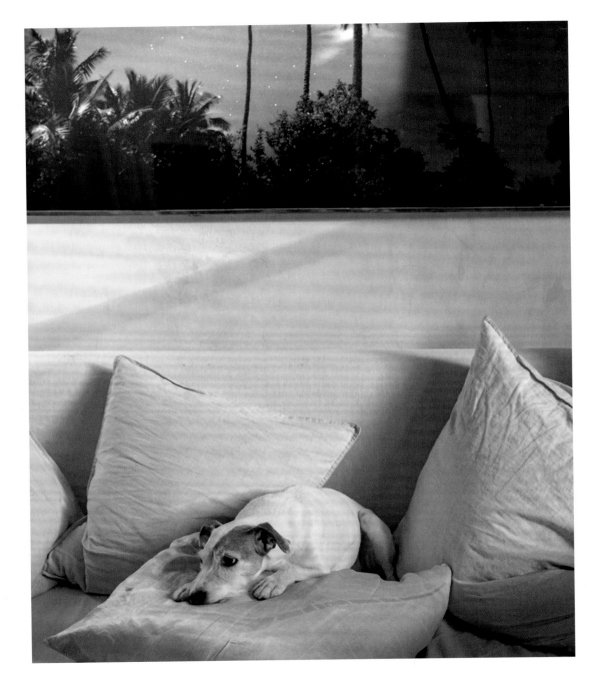

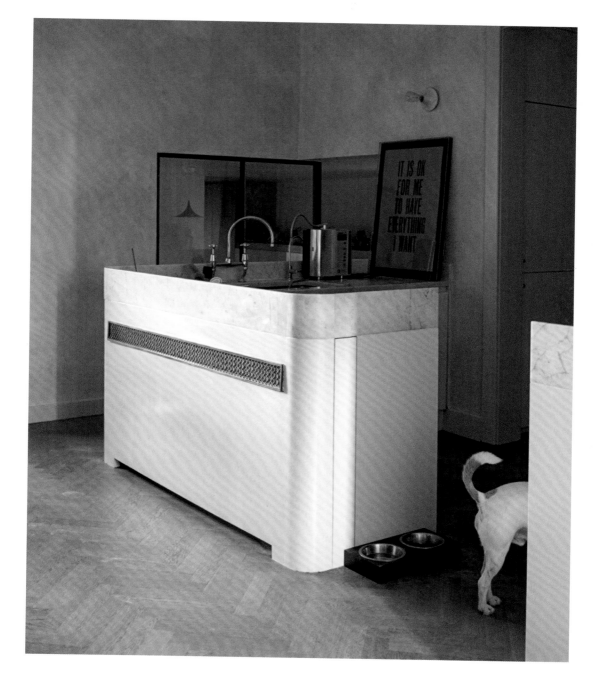

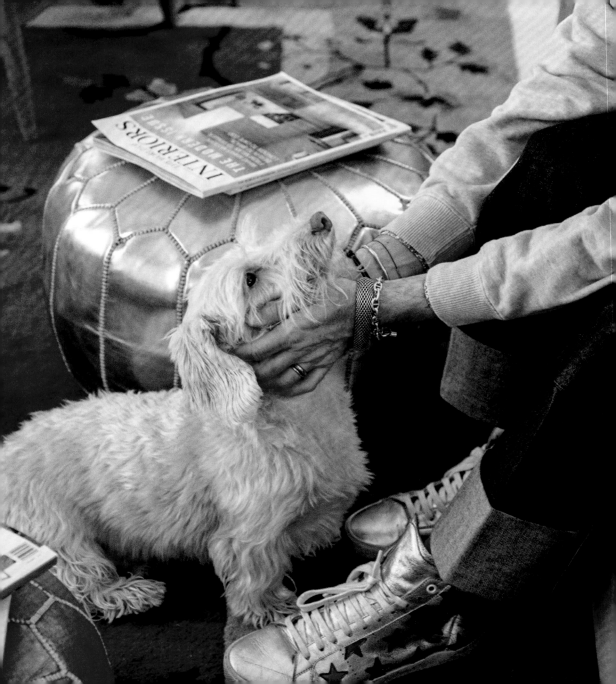

Rufus Marni Martin and Leilin

A warehouse in Brooklyn, NYC, is home to Martin and Leilin and their two wire-haired dachshunds, Rufus and Marni. Rufus is the blond, and Marni was black, tan and white, but is now silver-grey. Martin describes Marni as super-nosy, scrutinising every bag and parcel that comes through the door. She has never met a toy she can't pull apart. Rufus is more of a worrier and sighs with relief when Martin and Leilin get home, collapsing on their laps as if it's all too much. *Continued on page 240...*

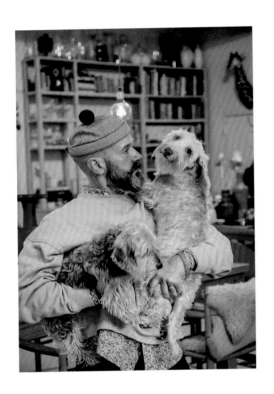

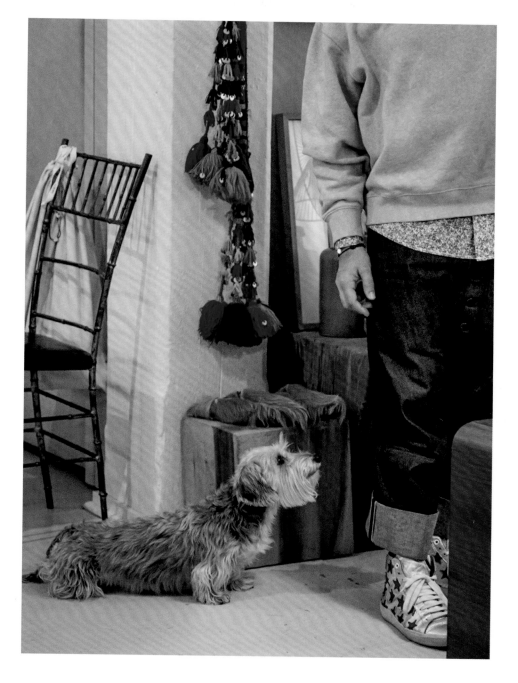

Rupert

Nicola

and

Nicola

Michael

22

Rupert is an English setter, a historic breed dating back two centuries. He belongs to Nicola and Michael Sacher, founders of the super-stylish pet brand Mungo and Maud. His day starts with a walk to work in Belgravia, London, their headquarters and first boutique. He sits near the shop window like a handsome sphinx, turning the heads of passers-by. Work for Rupert is doggy heaven because of the array of goodies around him. He wanders down the aisles with his tail swishing, admiring the doggy buffet on display. His main hobby is eating. Overzealous tail wagging can lead to accidental-on-purpose treat calamities. *Continued on page 241...*

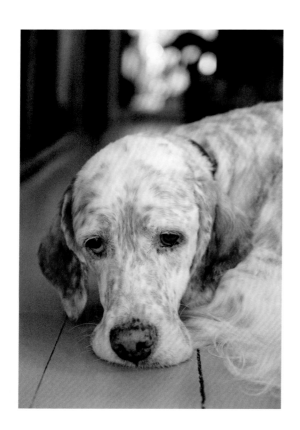

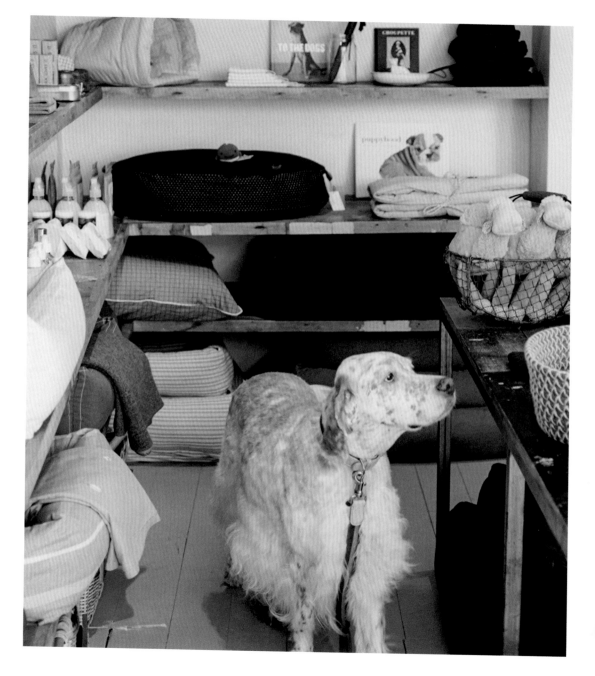

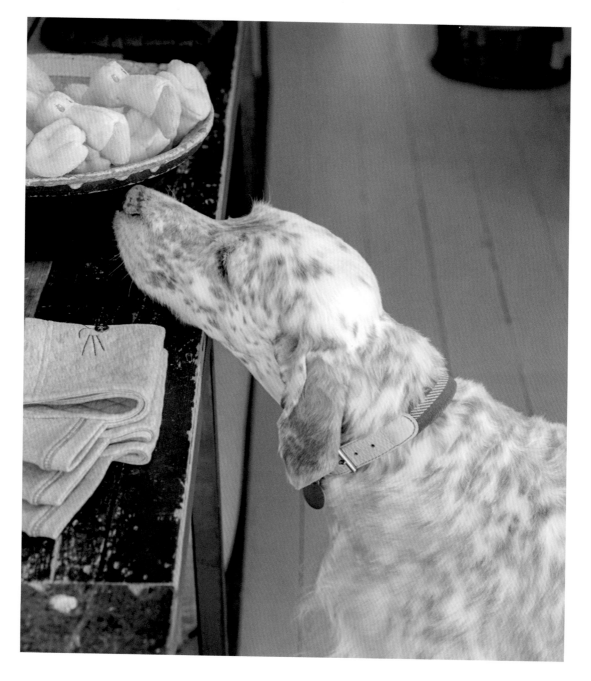

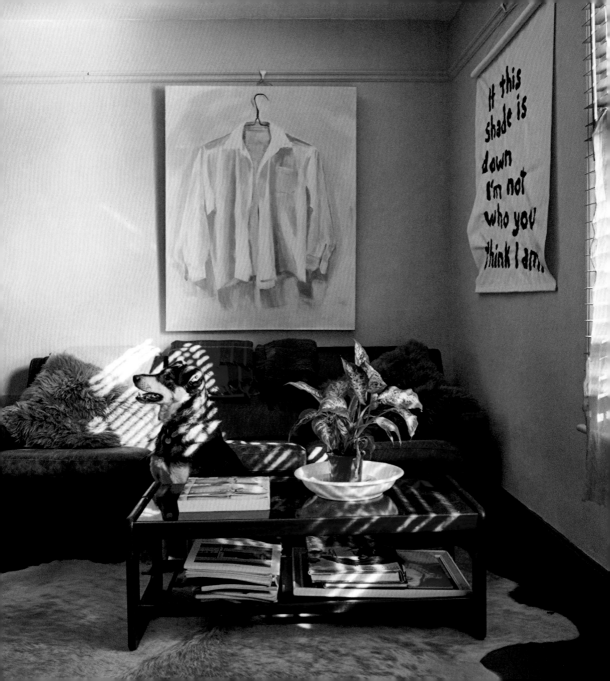

Spike

and

Lucy

23

When Lucy Merrell first met her dog, Spike, he was so feral she could hardly touch him. He was smothered in poo and completely terrified, having spent over twenty-four hours travelling from Romania in a van. Spike was picked up as a stray and spent six months in a shelter before Lucy's friend spotted him there and brought him to the UK with two other dogs. Lucy had a hard time getting her malodorous dog into her car to take him home, and after a big soapy bath and a good hose down, he stood, tail down, in a state of total shock. It was six months before Spike wagged his tail, and even longer before he finally started to relax. *Continued on page 242...*

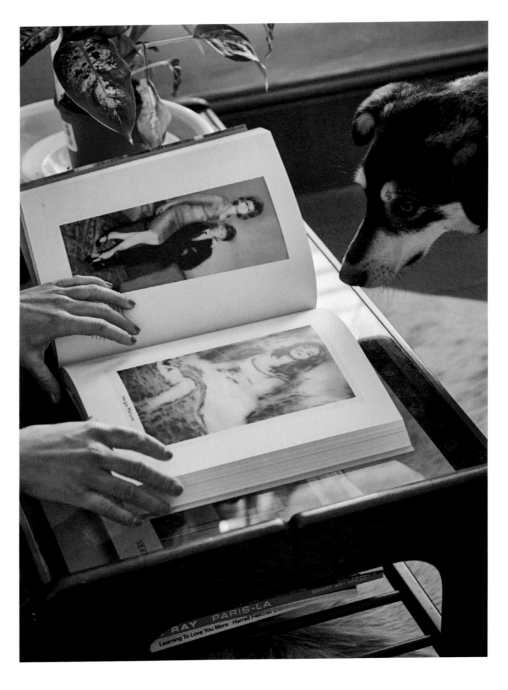

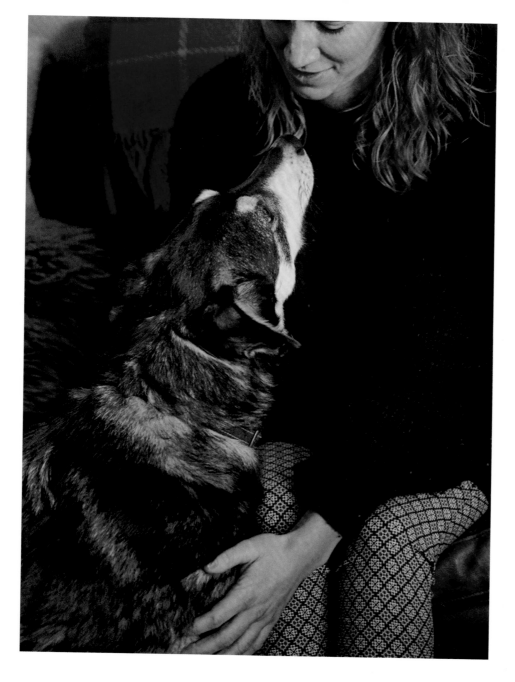

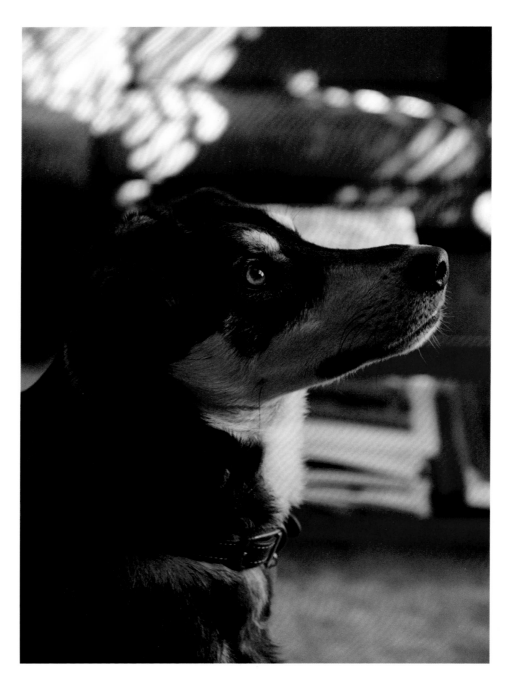

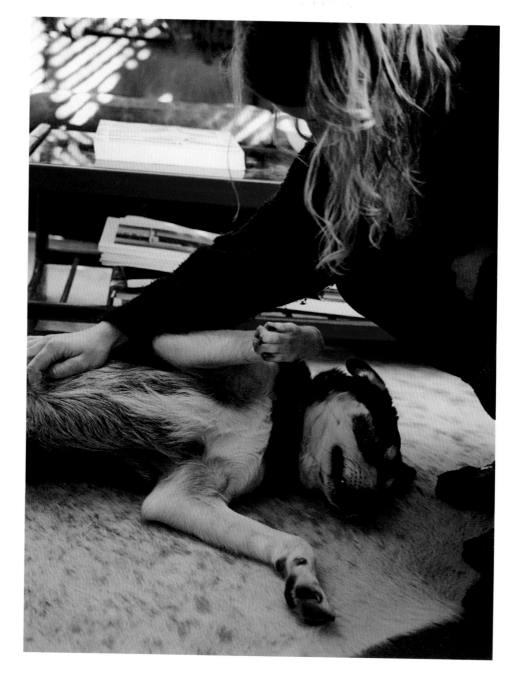

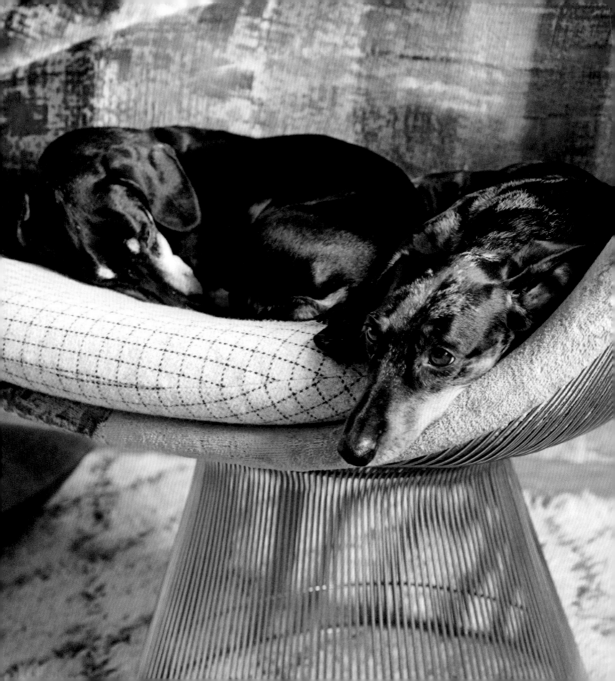

Sybil

Mark

Bette

and

Michael

24

Sybil and Bette are two dachshunds from very different backgrounds. Sybil was rescued from an abandoned flat in London as a very young pup. Bette is from a famous dachshund breeder. Bette is a standard smooth black-and-tan, Sybil a dapple. They live with Mark Homewood, a creative force at Designers Guild, and Michael Sharp, the costume designer responsible for the costumes at the London Olympics Opening Ceremony. Mark and Michael both grew up with large dogs, and had never thought about dachshunds until they moved in together and wanted dogs to suit their then London-based life. They now live mainly in the Somerset countryside. *Continued on page 243...*

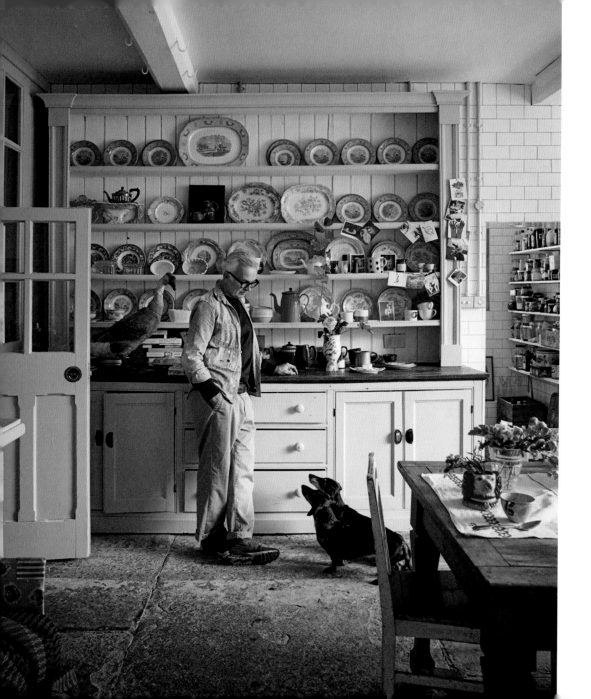

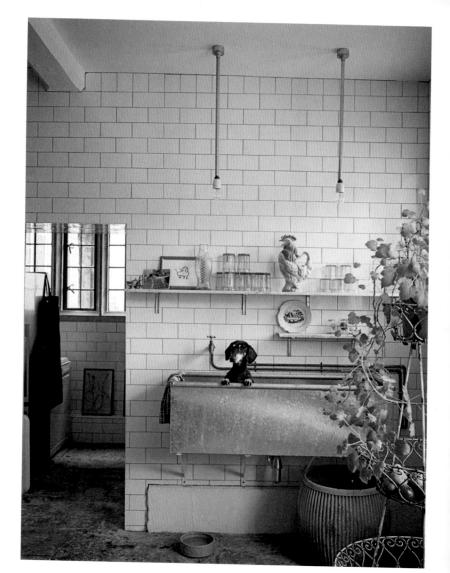

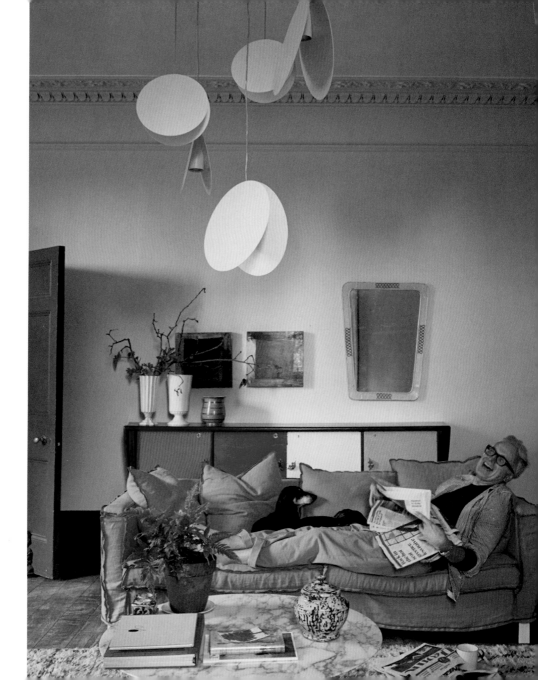

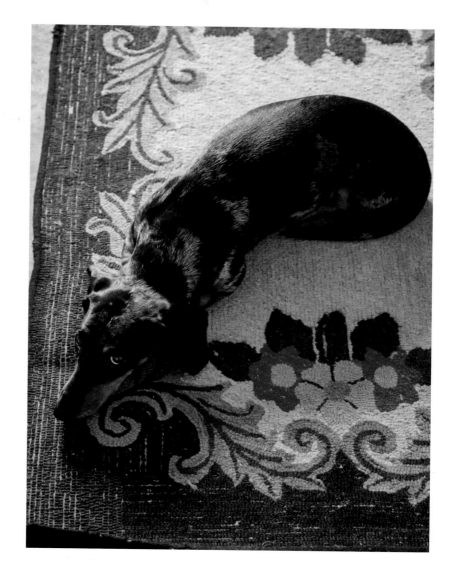

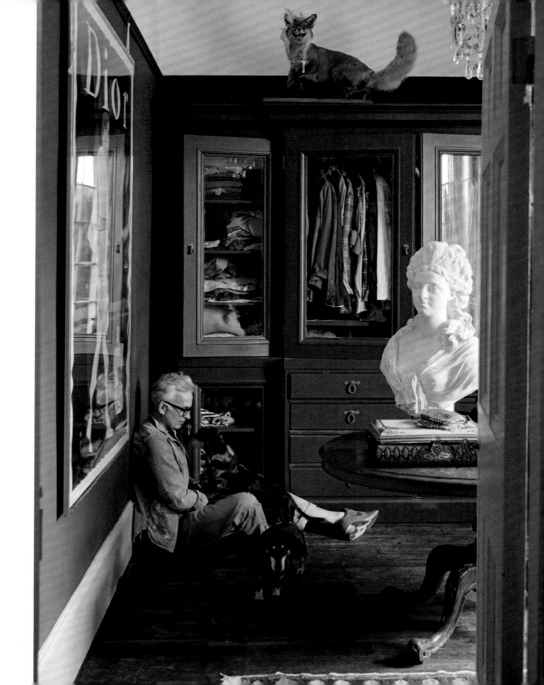

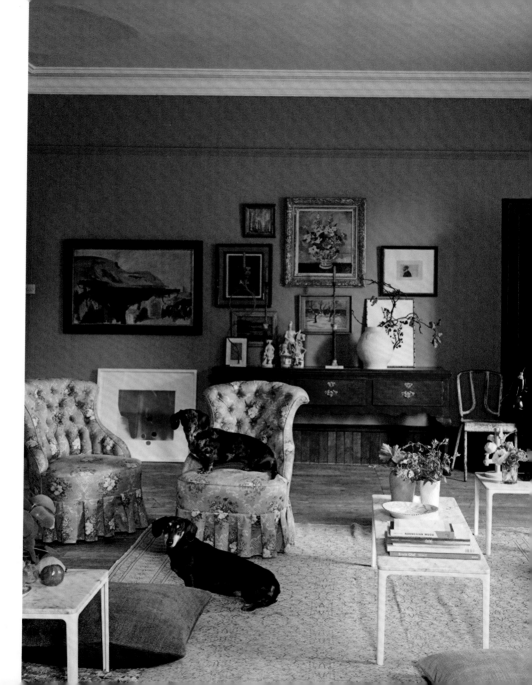

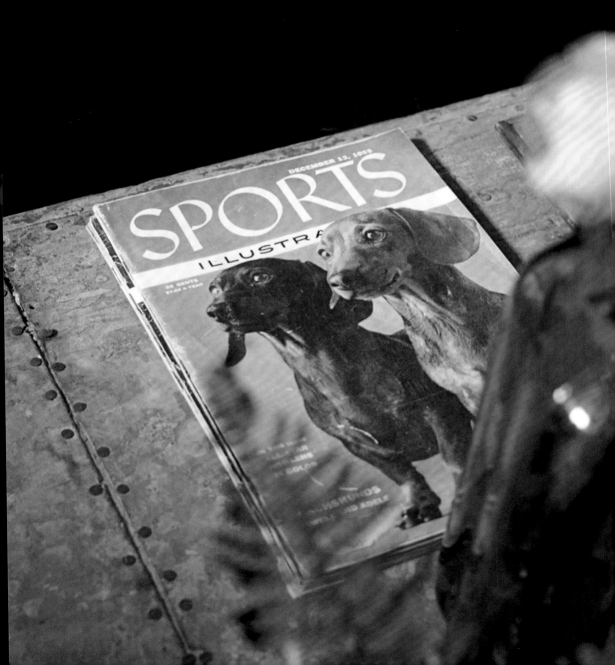

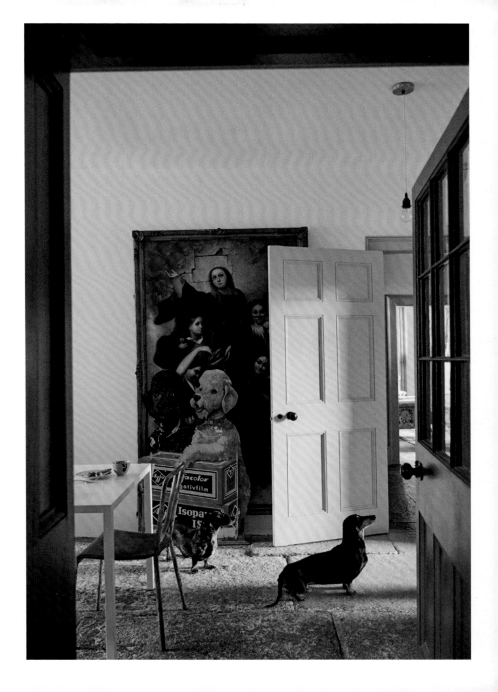

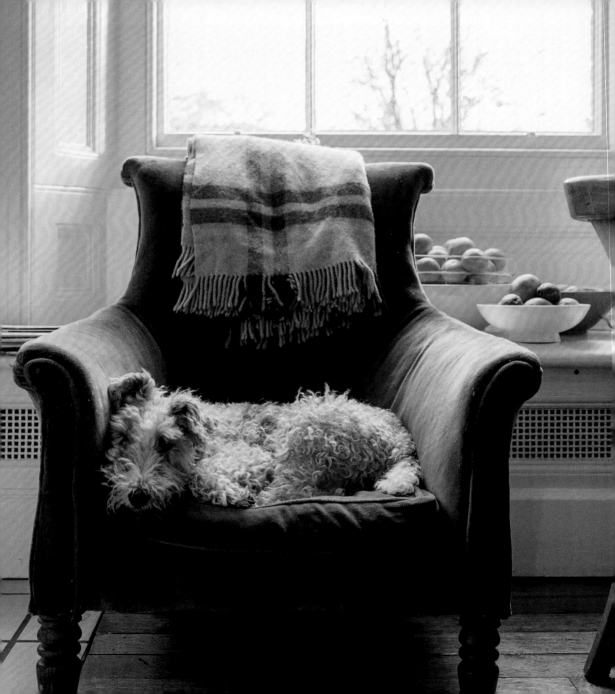

Tuppy Gussie

Terence

Vicki

and Hattie

25

Barton Court, in the Berkshire countryside, is the home of Sir Terence and Lady Conran (Vicki). Their two Welsh terriers, Gussie and Tuppy, have many acres in which to chase assorted wildlife, none of which they have ever caught. Their names were inspired by Gussie Fink-Nottle and Tuppy Glossop, characters from P.G. Wodehouse's Jeeves and Wooster stories. Both dogs are sweet, kind and devoted, with very different personalities. Gussie is the teacher's pet type — obedient, co-operative and anxious to please. Tuppy is inquisitive, mischievous and daring. They are, however, partners in grime, and both enjoy rolling in the smelliest patches of grass. *Continued on page 244...*

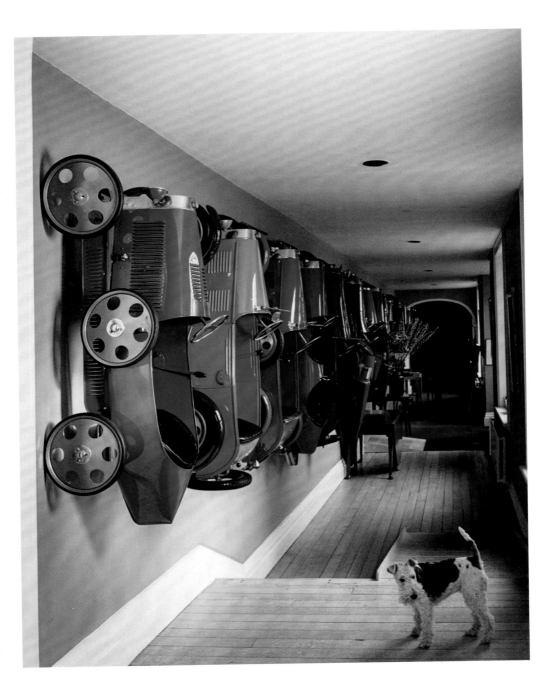

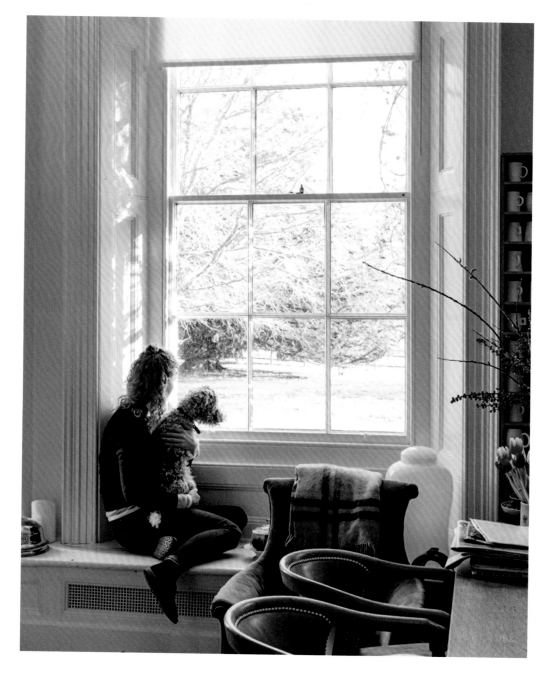

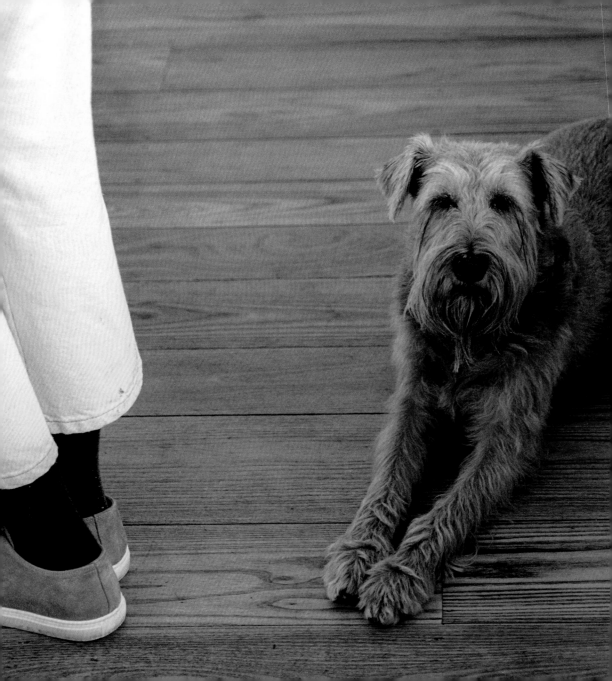

Wicklow

Paul

Ariel

and Daphne

26

Wicklow is an Irish terrier who lives in north London with Paul de Zwart, Ariel Childs and their daughter, Daphne. Weekends are spent at Rose Cottage, in Thomas Hardy country on the Dorset—Wiltshire border. Wicklow came from a man who knows and loves this breed, and interviewed Paul and Ariel at length to ensure they were right for the dog. The Irish terrier is among the oldest of the terrier breeds, chosen as messenger dogs during the First World War for their bravery, loyalty, sturdiness and speed. Wicklow is handsome, with a red wire-haired coat that needs hand-stripping just twice a year. Her eyebrows have two wisps with black tips, like a Fu Manchu moustache. *Continued on page 245...*

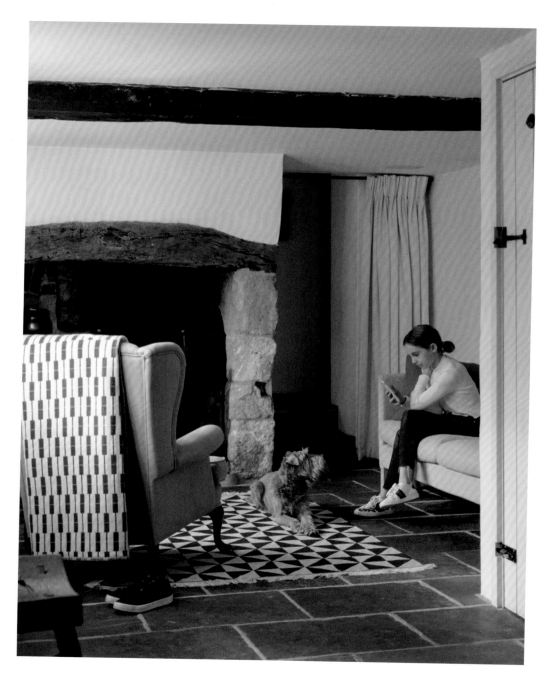

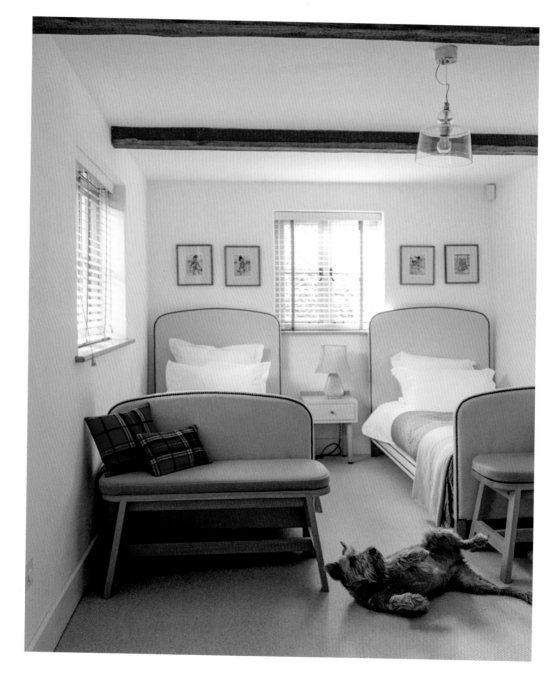

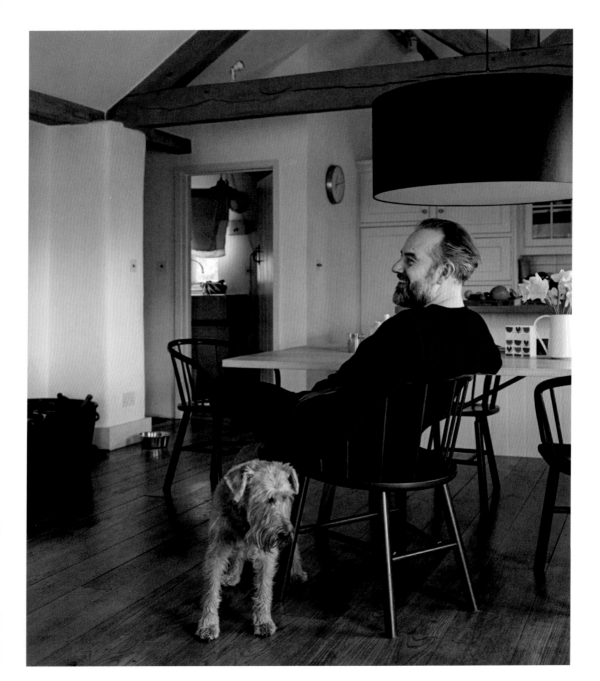

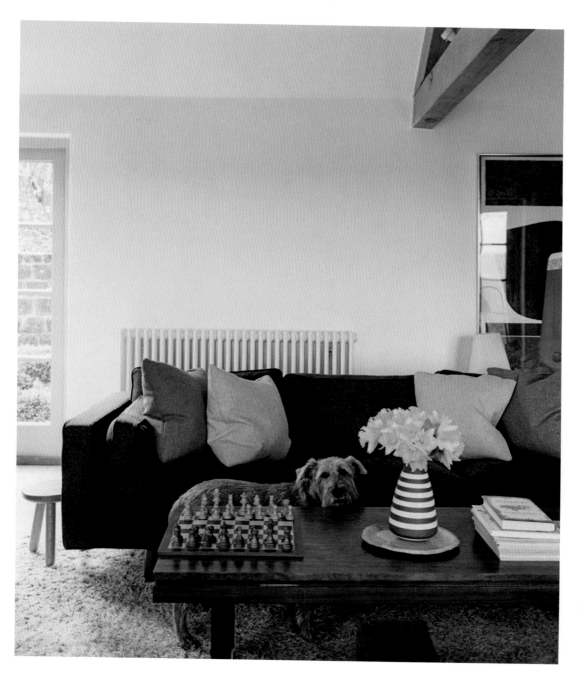

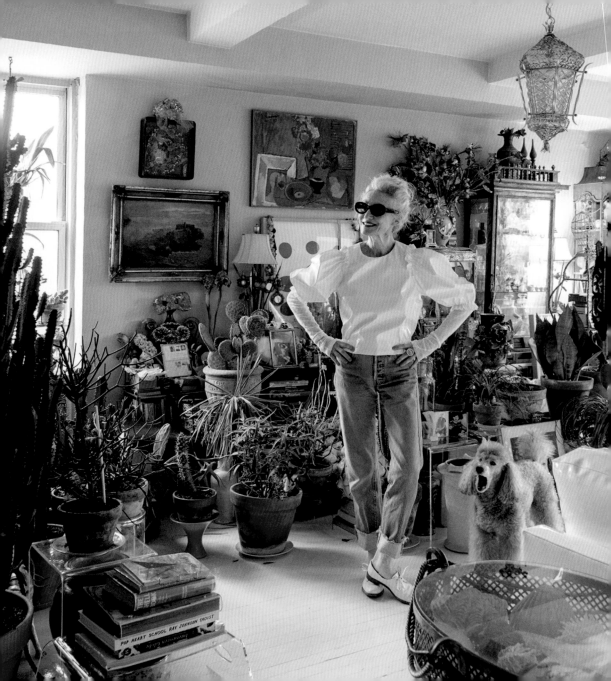

Winks

and

Linda

Linda Rodin is a fashion stylist and beauty guru, and the owner of Winks, a miniature silver poodle. When Linda visited a New Jersey breeder and saw Winks in the litter of pups, she knew he was the one for her — charming and beautiful, in a scruffy kind of way. Winks has become quite a celebrity in NYC since a giant photograph of him appeared in the window of Barneys department store. His wardrobe consists of a few cool sweaters and an eclectic collection of collars and leashes, all designed by Linda and made in the USA, which sell all over the world. She admits he is her muse and inspiration.
Continued on page 246...

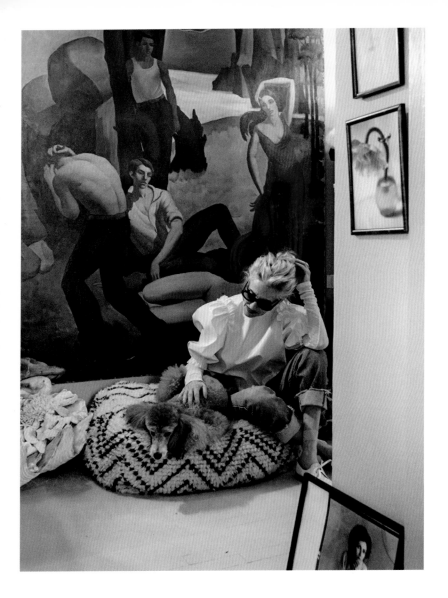

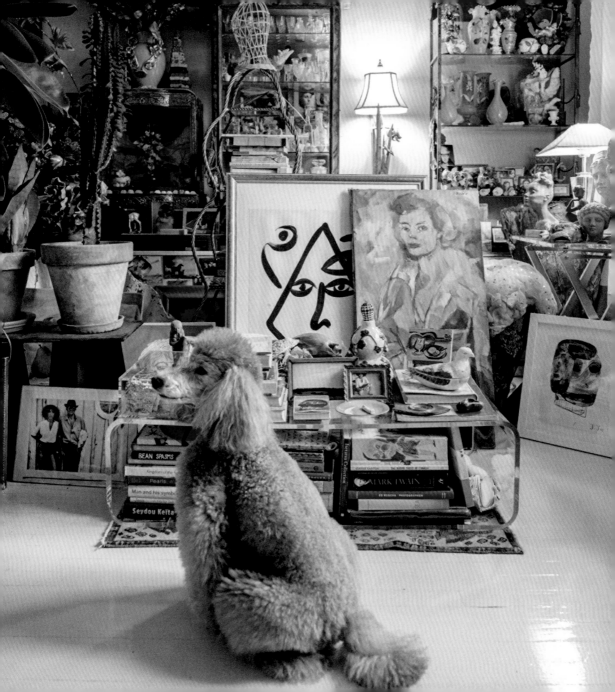

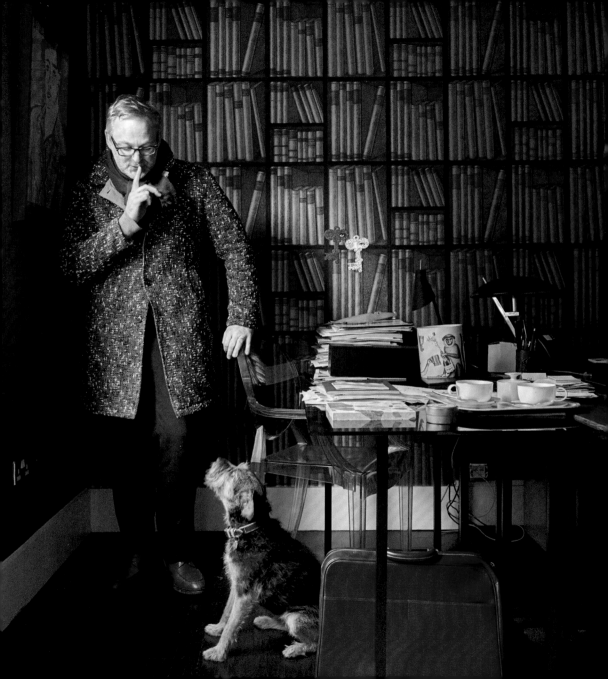

Wolfie

Otto

Laurent

and

Chris

28

Wolfie and Otto are Border terriers, and are shared between Laurent Delafon and Chris Yu, the founders and co-owners of United Perfumes. Every day, the dogs travel by bus or Tube to the company's offices in a tall, five-storey Georgian house near Marble Arch in London's West End. Wolfie is blue and grizzle and very grand — his father has been the star in many dog shows. Otto is grizzle and tan, and came from a first-time breeder. Wolfie and Otto are popular and valued members of the United Perfumes team. Chris says you can tell when a team member is taking a stressful phone call because one of the dogs will be at their feet, calming them. *Continued on page 247...*

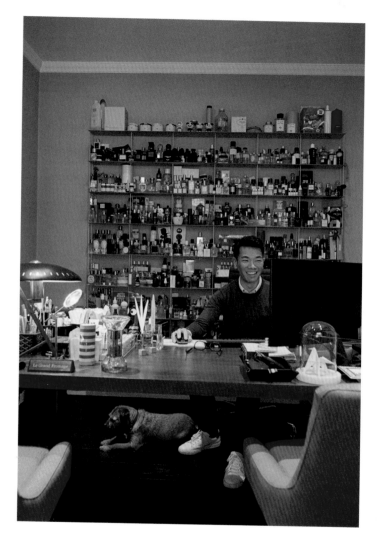

Bernie

Jeremy

Cath

and

Milo

29

Cath and Jeremy Brown's young dog, Bernie, is half German pointer, one-quarter collie and one-quarter Labrador. He is tall, handsome, clever, gentle and tolerant, displaying the extreme intelligence and sensitivity of the collie along with the companionship and loyalty of the Labrador. Pointers are often watchful over young children, and Bernie rarely leaves the side of his best friend, Cath and Jeremy's son, Milo. They seek each other out and curl up together, linking hand and paw. If Bernie is sleeping on the floor, Milo will join him, resting his head on the dog's back. Their bond is awe-inspiring; they are inseparable. *Continued on page 248...*

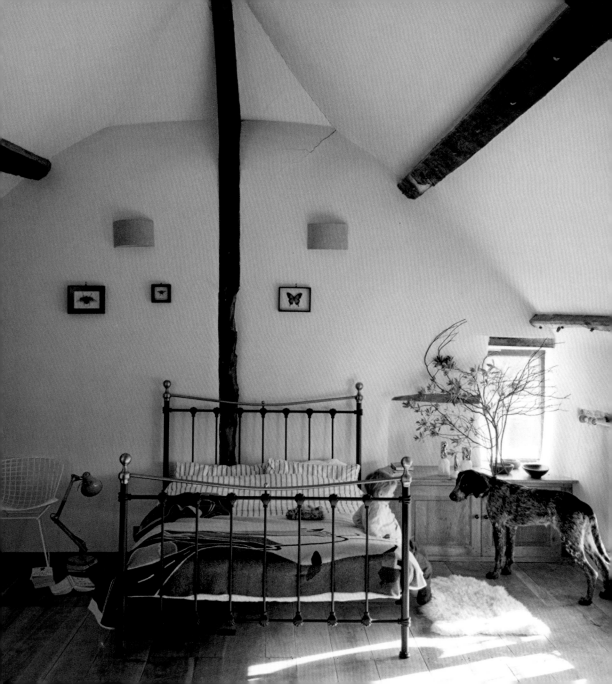

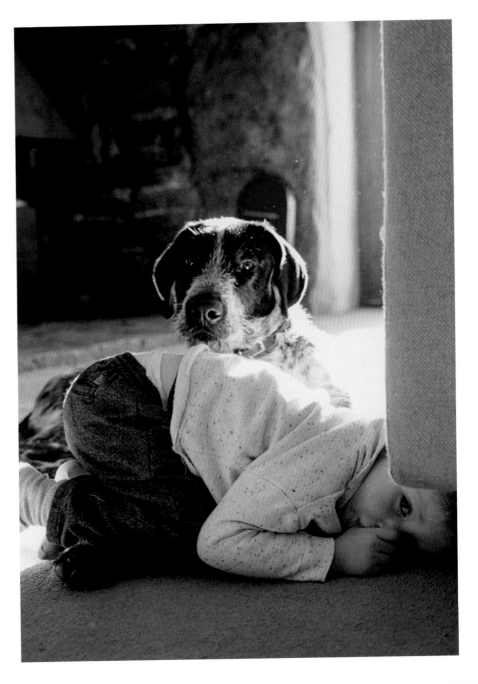

Lulu

Lola

Giby

Nino

and Sibylla

30

Giby and her two daughters, Lulu and Lola, are wire-haired dachshunds who live with the renowned fashion designer Nino Cerruti and his wife, Sibylla, in their traditional Italian villa in Biella, Piedmont. Giby is an intellectual, unlike her daughters. Lulu's nickname is Miss Vogue because she is constantly posing and loves being groomed, while Lola is very sociable and makes the perfect hostess, always welcoming and never too chatty. They are like a human family — Giby loves to read, Lulu likes to admire herself in a mirror and Lola organises everyone. *Continued on page 251...*

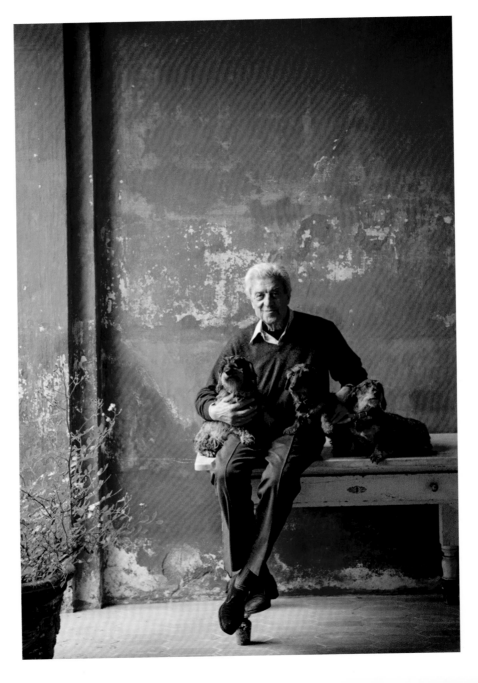

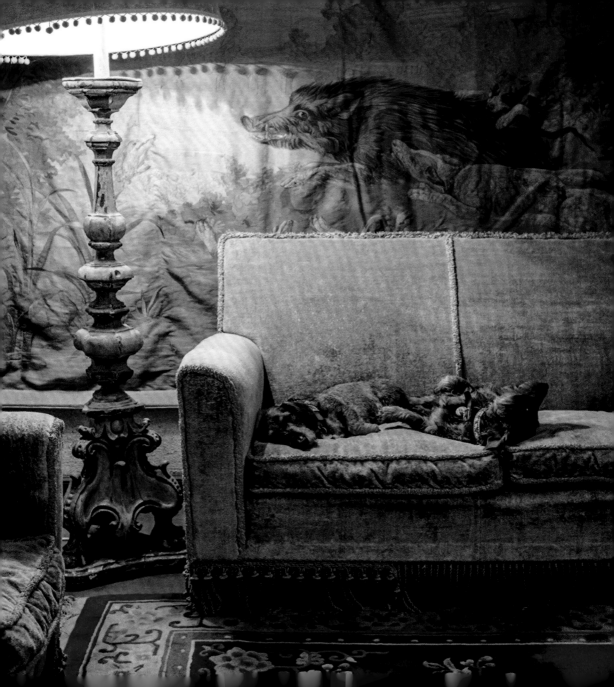

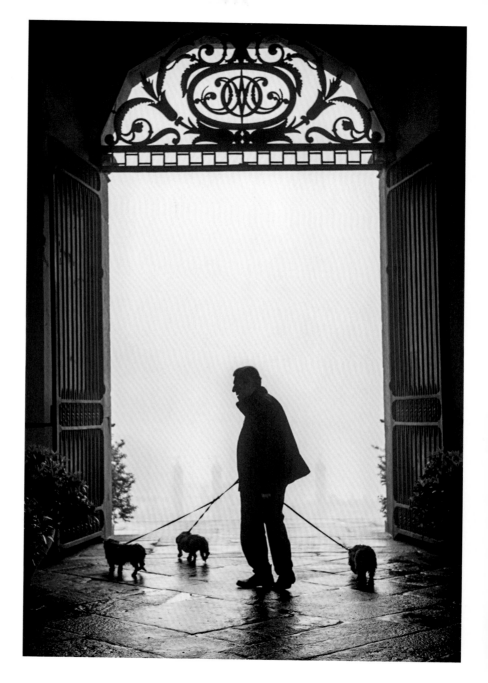

Otto

Mark

and

Polly

Otto, a standard Parti poodle, lives with Mark Gilbey, a furniture designer, and Polly Dickens, former creative director of Habitat and Conran, in a listed Georgian house in Whitechapel, in London's East End. The word 'Parti' comes from 'particular', meaning this type of poodle has very distinctive markings — their coats are typically half white with well-defined black markings, almost as if painted on, and small black dots, like random brush strokes. Otto is a beautiful example of the breed — he would have looked sensational strutting along the catwalk in a 1960s Mary Quant show, and Polly and Mark are convinced that since Otto's arrival, their decor has become more black and white. *Continued on page 252...*

Continued on page 252...

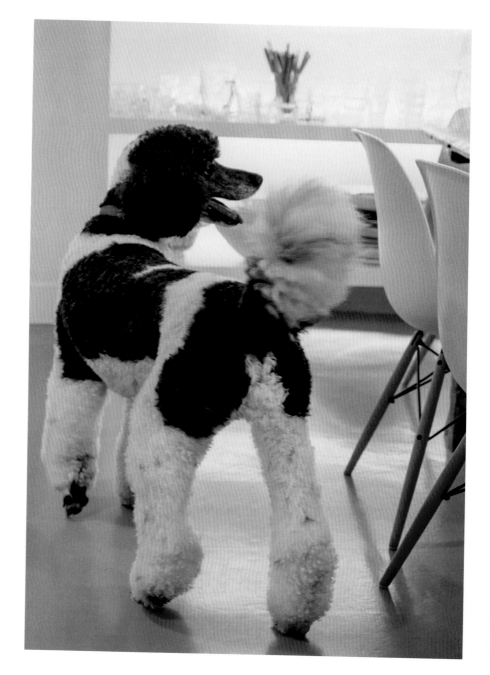

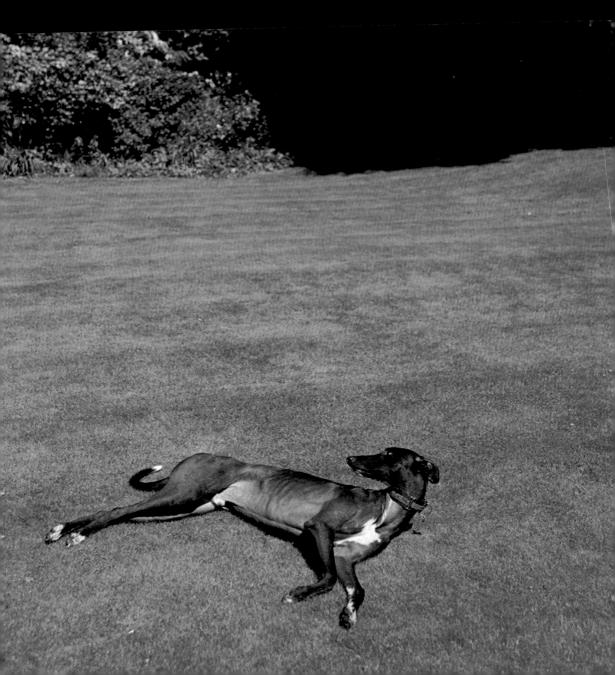

Bluebell

and

Jilly

32

My abiding memory of Jilly is of her wonderful laugh, and, of course, her gorgeously gapped teeth — she's still very much the flirty author of the *Rutshire Chronicles.* We received a very friendly and warm welcome, lots of tea and biscuits, at her home in the Cotswolds, deep in the English countryside. Her house is wonderfully chaotic, full of pictures, books, knick-knacks, plants and animal ephemera, with a huge lawn and gardens, which also features an old tennis court and dog graveyard. Jilly often writes outside, kept company by Bluebell — a black Irish greyhound, a retired racer from Ireland. *Continued on page 253...*

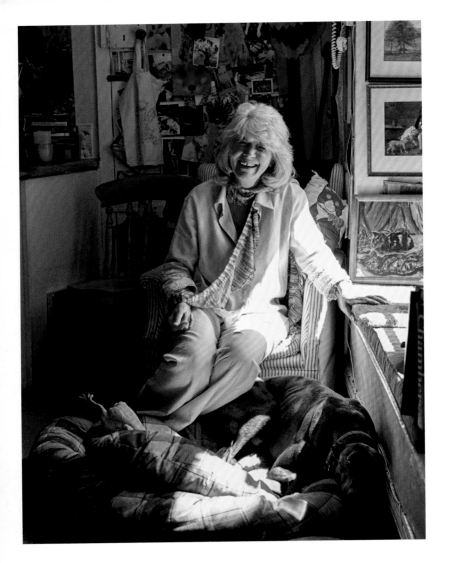

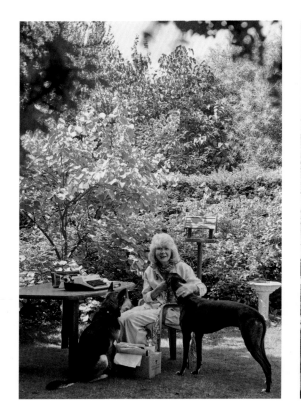

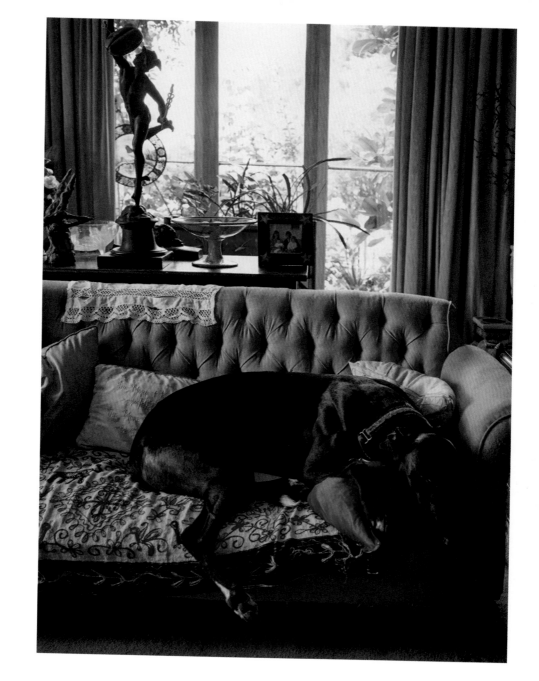

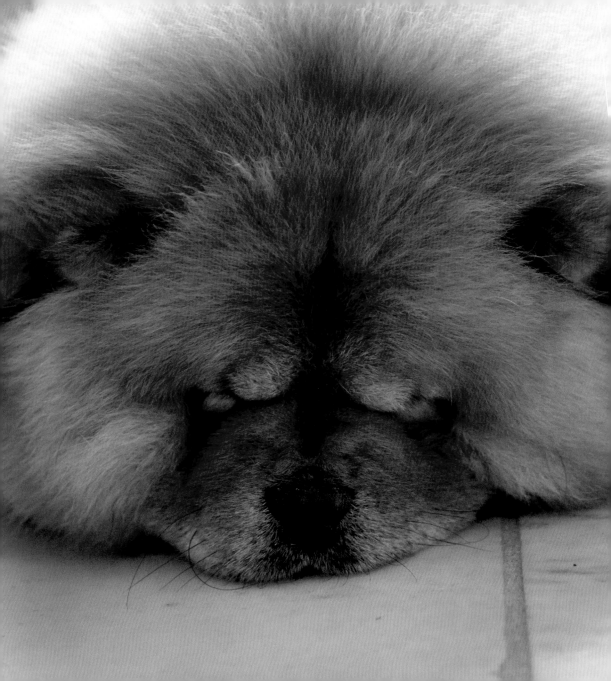

Bête Noire

Crème Brûlée

Empress Qin

and Martha

Home-making icon Martha Stewart shares her Connecticut home with two affectionate French bulldogs — a brindle called Bête Noire and his fawn sister, Crème Brûlée — and a rather more aloof and independent Chow Chow, who goes by the aristocratic name of Empress Qin. They are but three animals in a diverse collection that includes cats, chickens, donkeys, a fell pony and five magnificent Friesian horses — but it's her dogs that Martha is eager to return to at the end of each day. *Continued on page 254...*

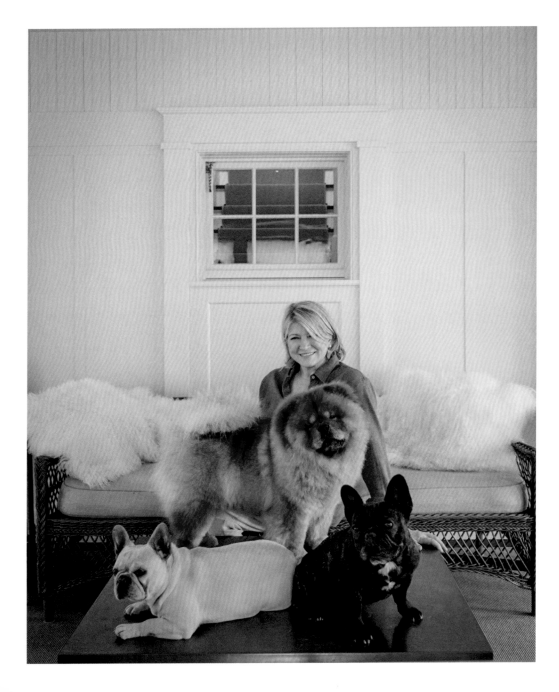

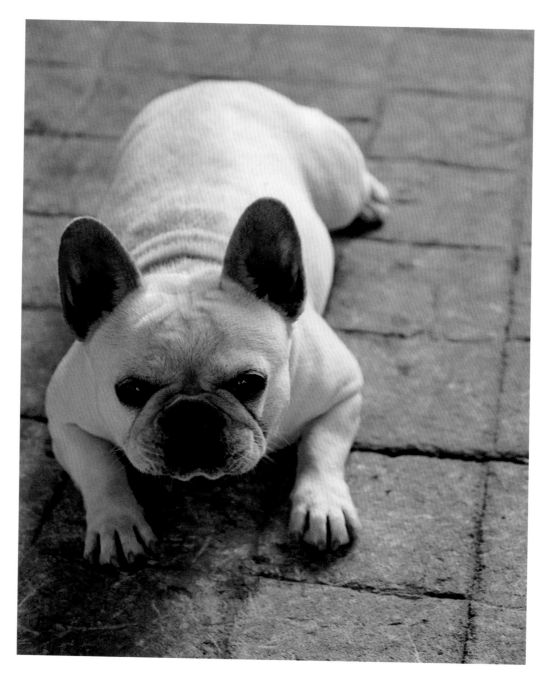

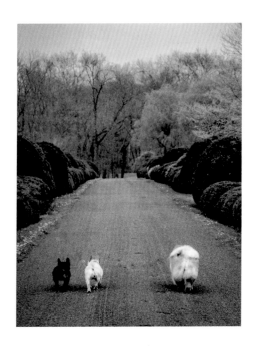

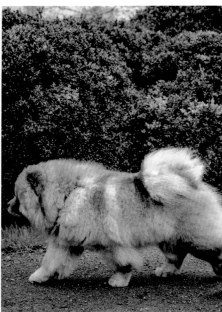

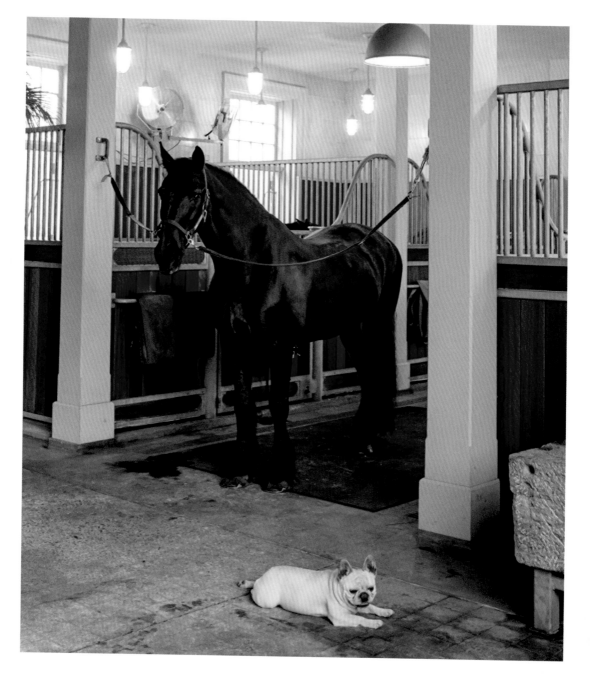

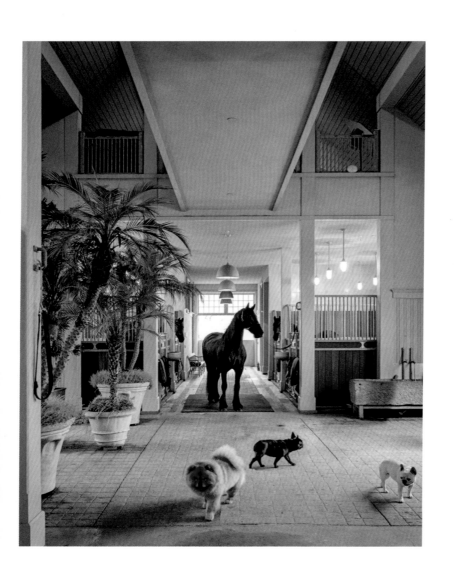

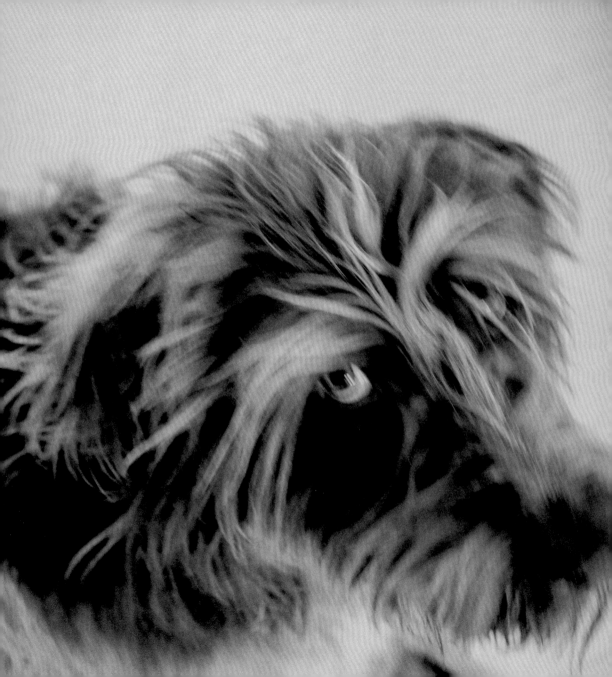

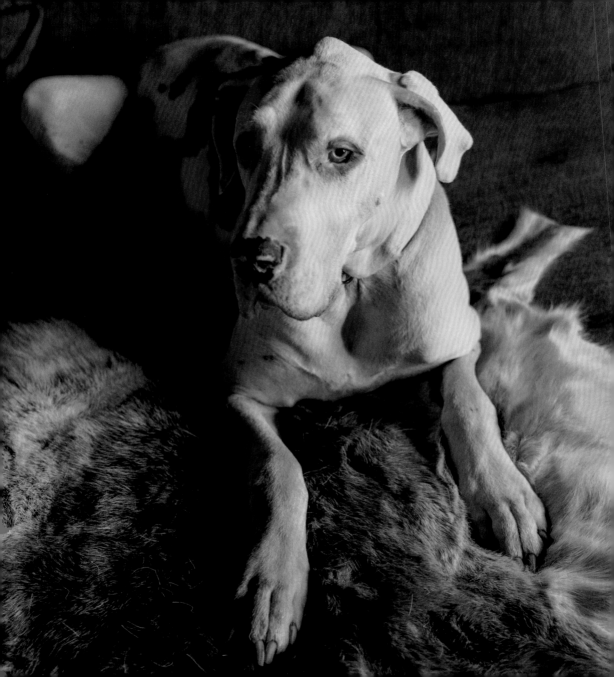

Quinn, Toby, Mimi and Alex

Continued from page 7

The monastery is now Alex's home and showroom, visited by customers from all over the world. The small cottage on the side is a cosy living space, while the monastery itself houses her vast eclectic mix of treasures, ranging from the fifteenth century to mid-century modern. The building has gone through various reincarnations, from a malthouse to an army barracks and military hospital, a theatre and a dance school, and was last used as a pottery — the white potter's dust still snowing sporadically from the rafters of the vaulted ceiling.

It then lay empty and decaying for ten years, but against all advice Alex decided the monastery was for her and her dogs. She sold her house and bought the damp, uninhabitable building, moving herself and the dogs into a caravan in the muddy garden. There they lived for eighteen months while she set about converting the adjoining cottage for the four of them to live in. She tore down false ceilings and walls and banished the pigeons, uncovering stone windows and revealing the great monastic proportions of the building.

The dogs, meanwhile, meandered through rubble and mud, but found their cosy corners. They now enjoy life dozing on antique sofas, chairs and four-poster beds, though their favourite spot is in the cinema room, snoozing on a long modular sofa with a reindeer skin while Alex watches a film. At night, they all sleep together in Alex's study, which is part of the monastery but attached to the cottage, their three beds merging into one by the radiators. They can't sleep in Alex's bedroom, she says, because Quinn, who is the size of a small horse, can't get up the very narrow cottage staircase, and she couldn't bear to exclude him, so they all stay downstairs.

This happy, unconventional home has its quirks. Alex mentions that occasionally a ghost-hunting tour bus swings by because there is a rumour that twelve monks were buried alive in her garden. One low, bellowing bark from Quinn sees them turn at heel, eager to get back on the bus.

Continued from page 15

Bean is the outcome of Carol's online search for a breed of small dog that doesn't bark and needs little exercise. Mi-Kis are intelligent and Carol says Bean is incredibly smart. For instance, she never barks when the concierge rings twice to announce a visitor arriving in the elevator, but if the elevator stops without the concierge's call, she barks to alert Carol to an unannounced caller.

Bean is too small to jump on the furniture, but Carol is always happy to scoop her up. She's partial to a glass of iced water (preferably a tumbler), which she sips while sitting on Carol's lap. She eats dried puppy food mixed with fresh chicken, and enjoys treats of crushed liver cookies. She sleeps on Carol's bed, but is happy to go in her crate when she's home alone. Carol takes her everywhere she can, but restaurants tend to be a problem. She tries to hide Bean in her bag, but when the food comes Bean pops her head up like a little monster, resulting in both of them being asked to leave.

Bean's main form of exercise is scrambling around the apartment after a ball, sliding along the floor. Carol's apartment is a mix of contemporary and classical, though all of the classical features are fake, she says. The walls look like marble, but are wallpapered. The giant floor tiles are plywood painted in muted tones of pink. Carol loves *trompe l'oeil* and Graeco-Roman style, though only if it's not too serious — her favourite is a faux marble Doric column.

Carol never thought of herself as one of those Park Avenue women with their tiny groomed dogs (her first pet was a monkey). In the park, she feels she should have a sign on her back announcing that her last dog was a greyhound — but she wouldn't change Bean for the world.

Continued from page 19

Matt is the founder of a men's lifestyle magazine called *Wm Brown* and author of *A Man and His Watch*. Yolanda is the founder of a travel quarterly called Yolo Journal. Matt met the Austrian architect Oskar Leo Kaufmann in Milan when he was working on a shoot for Wallpaper magazine. Kaufmann had designed a temporary glass-box house for a Design Week event, which so impressed Matt that he commissioned him to design the couple's country retreat. The prefab resembles a modern alpine cube with a warm textural interior of solid oak floors and oak veneer walls.

Charlie was born in California and looks like a mini Labrador retriever, with his glossy black coat and purposeful stare. His ancestors are from the Lake District in the north of England, where they were bred in a harsh climate to hunt foxes and badgers. Life is good for Charlie; he has 130 acres in which to practise his hunting skills.

At twelve weeks old, Prune travelled from a small French village called Saint-Yzans-de-Médoc to NYC via Paris. She loved the long journey, particularly the flight, where she snuggled into a fleece blanket, staring out at the clouds. Prune was thrilled to meet Charlie, but he was less than thrilled to meet Prune. However, her sweet, charming nature has mellowed Charlie somewhat.

Charlie is obedient and independent, the opposite of Prune, who can be obstinate. Prune enjoys a cuddle, especially in the evening, whereas Charlie is not an evening dog at all. He takes himself off to his bed where he will stay until the morning, when he springs into life. Charlie is an excellent watchdog and is not as yappy as Prune. She is a busybody but has a good sense of humour, and on occasion she has even managed to get the serious Charlie to lighten up and play.

Charlie loves to lie in his bed next to the window. It's the best spot from which he can scan the scene below for furry intruders. He does occasionally share the bed with Prune, though she prefers the sofa. The Hans Wegner day-bed in front of the window is another favourite reclining spot for them both.

Matt and Yolanda never planned to have two dogs, but fell in love with Prune when they saw her in France and thought she would be good for their unsociable Patterdale. The plan worked. Charlie has become a more emotionally stable dog and is more loving and lovable. The only downside, says Matt, is picking up two piles of poo.

Continued from page 23

Ann Marie is a journalist and writer and has worked for the *New York Times*, *Monocle* and *Tatler*. She was the founder of *Modern Farmer* magazine, the first publication to celebrate agriculture, and the first independent magazine to win the National Magazine Award. She works from home on her latest project, Tempest. It is a weather-lifestyle brand she describes as a Goop or Vogue for weather in a changing world, as we are living now at the intersection of weather and climate change. Ann Marie finds she always works better with Thurber and Ciccia at her feet.

When Thurber's mugshot appeared on Pet Finder, a website matching unwanted pets with new owners, he was already on Death Row. Ann Marie wanted him immediately. When he arrived, his paws and legs were in very bad condition from running too much. He now has arthritis, but he still likes running. He's a wonderful companion and always senses when you need comforting. He's like a walking cabinet of curiosities — everything seems to stick to him, you never know what you'll discover entangled in his coat.

Ann Marie's godson spotted Ciccia on the street when they were on holiday. She couldn't resist this unwanted little dog and within a week, Ciccia was on a plane to join Thurber: 'I brought her to NYC at ten weeks. It was something to watch her strut her stuff like a cabaret star and land at JFK in the snow.' Thurber was not happy at first — he was growly and then just sulked — but he soon warmed up and Ciccia is one of the few dogs that can really get him playing. Ciccia is wilful, entitled and demanding. She's timid at first with new things, but she had to fight with her three brothers for food in the Dominican Republic, so she's pretty tough.

Ann Marie bought the 1800s house, complete with a kerosene stove and tiny electric heaters, from a couple who had lived there for eighty years. Then, it was dark and depressing; now it is modern and uplifting, with uninterrupted views down to the Hudson River. A 1960s Scandinavian fireplace has replaced the heaters. Ciccia's favourite seat is also from the 1960s, a faux-fur, gold-coloured lounger that matches her coat. Linen is thrown over most of the upholstery so nothing is out of bounds to the dogs. At night, Thurber and Ciccia sleep on the bed with Ann Marie. Ciccia loves to snuggle into her armpit, Thurber loves to sleep on his back with his legs in the air. Ann Marie's favourite acquisition is a portrait of the dogs dressed up as sheriffs by Hudson artist Earl Swanigan.

Ann Marie rarely leaves her Germantown home now, as everything she needs is there: 'I have my Buddha to relax me and my Coochie Mama who makes me laugh, you don't get better than that.'

Continued from page 29

The building was originally a flophouse for sailors in the 1880s, and is now a hive of activity, full of interest, light and life. The ground floor houses Caroline's studio, where she designs jewellery for her label, Brvtus. The second floor belongs to Sub Rosa, Michael's strategy and design practice.

Caroline, Michael and Darryl live on the top two floors, with a double-height ceiling and exposed brickwork. The generosity and beauty of the space is not lost on Darryl. He strolls around, stretching out on a Moroccan rug or slumping down on his favourite wool sofa. Much of the furniture has been designed by the Venturas and made locally.

Darryl never ventures up the spiral staircase. He once climbed up, got stuck and had to be carried down by the builder, an experience he's not anxious to repeat. Caroline and Michael subsequently built a second, Darryl-friendly staircase so he can now join them upstairs at bedtime. They have an extra-large bed because Darryl sleeps on his back with his legs in the air. He is often last to get up in the morning, and sits on the top step with his front paws dangling over with a bedhead hairdo. He's not very athletic — Caroline thinks that, as a human, he would have been on the chess team, not the football one.

Darryl has a wild mane of soft hair, large, expressive oval eyes, thick eyebrows and a laid-back demeanour. He would probably speak with a posh, slow, monotone English accent. He's very vocal and makes his disdain clear by sighing and rolling his eyes; he's also very good at a dismissive side glance. He has a favourite couch and a favourite toy, a flattened and chewed cloth bear. He loves to sit with his chin resting on the back of the sofa, his huge hazel eyes fixated on Caroline, wondering what will happen next. He loves squirrels, socks and sticks, and his best friend is a Great Dane called Roquefort, with whom he walks every day. At the weekends, he enjoys hiking with Caroline and Michael.

Caroline and Michael used to give Darryl raw food, but he likes to play paw billiards with his bowl, often distributing the contents around the room, and occasionally they'd find a raw chicken neck on the sofa. Now he eats dried food mixed with fresh vegetables — displaced kibble is easier to deal with. Sometimes he pushes the kibble under the sofa, enjoying the challenge of retrieving it with his paw. His table manners are so hilarious that Caroline occasionally shares videos on Instagram, called Dinner with Darryl.

Darryl can be brattish sometimes, standing next to the treat cupboard and barking until he gets what he wants. The problem is that he's wildly entertaining, everybody in the neighbourhood knows him and makes such a fuss of him — that he lives on Planet Darryl.

Dumbo, Moon and Heyja

Continued from page 35

Dear Rivington is an exquisite lifestyle store, selling a mixture of fashion and interior pieces. Some are vintage, some are new — from Comme des Garçons to their own Dear Rivington label. From the whitewashed brick walls hang antique bags and necklaces and hand-dyed lace, Yohji Yamamoto coats and jewellery from the collection of Heyja Do, Moon's wife. Heyja's grey- and chalk-coloured pots, fresh from one of her exhibitions, cover the floor at the front. They are now much sought after.

Moon and Heyja brought Dumbo home when she was just eight weeks old, at the end of a dinner party. They were at the house of a guy in Coney Island who was a bull terrier breeder. He had two pups and the female pup followed Heyja and Moon around all evening.

Moon has apologised many times to Dumbo for not bringing her brother home too; he didn't realise how intuitive and sensitive his dog would be. Dumbo hates to be alone, and Moon is careful to respect that. Dumbo is bilingual — Moon and Heyja speak to her in Korean and sometimes English. She understands exactly. Dumbo distinguishes people by name, and if they ask her to sit by any of their friends, she always chooses the right one.

Dumbo loves children and the younger the child, the more gentle she becomes.

She is very different from Moon's last dog, a black Shar-Pei, who didn't really like other dogs. Dumbo is a friend to everybody — cats, dogs, whoever. When a customer comes into the store, she runs over to greet them.

Dumbo is a very polite dog. She sleeps at the foot of Moon and Heyja's bed, but when she wants to jump on the bed she always asks Moon first, nudging him gently to check if it's okay. He then gives her a little pillow, because she doesn't sleep as well without it.

Moon and Heyja cook salmon and lots of vegetables for Dumbo; she also loves home-made beef patties and broccoli. 'We look after her as best we can and we feel so lucky to have her,' Moon says.

Dumbo is a very special dog and many people stop at the store simply to say hi to her.

Continued from page 43

The riad and gardens were designed by landscape architects Eric Ossart and Arnaud Maurières to be a calm, soothing place, with only birdsong and the occasional cry of a peacock interrupting the silence. The entrance is through a modest aubergine-coloured door, leading into a white rose garden bordered by vegetables. The courtyard flows into the large, low, contemporary building, designed to reflect the ochre tones of the earth, which is almost hidden by cacti, palms and pools. When Ossart and Maurières moved on to another project, Ollivier bought the riad as a refuge, but soon made it his permanent home. He engaged local craftspeople — from weavers to potters, metalworkers to woodcarvers — to create the unique pieces that make the riad, now open to guests, so very inviting.

Ollivier's first canine companion was Idir, whose owners moved away and needed to find a home for him. Then came Max, the biggest of the five, whose callous owners — neighbours of Ollivier — drove their flea and tic-infested hound 19 miles away from home and dumped him. Two and a half months later, he arrived, shattered and emaciated, on Ollivier's doorstep. Max returns Ollivier's kindness to him with quiet loyalty. Lina, who — ironically, given her owners' reason for abandoning her — is Ollivier's quietest dog, slumbering most of the day on a Bertoia chair at the entrance to his office.

Stray dogs are a huge problem in Morocco and the authorities have a cruel policy of leaving poison-laced food at the side of the road to reduce the numbers. Linda, a mere pup when Ollivier found her, was an intended victim. Ollivier fell in love with her wild hairdo, brown button eyes, beautiful nature and fondness for a cuddle and she was promptly added to the household. And Ollivier's resolve that four dogs was enough crumbled when Diablo, a black and tan puppy with mismatched ears and huge paws, materialised — left for him anonymously by, he suspects, a member of staff.

Most guests who come to the riad live in apartments or busy cities where they cannot keep a pet, and they find being with the dogs and cats therapeutic. The dogs never bother the guests but are happy to receive a stroke or a cuddle before trotting back into the shade of the palms to stretch and snooze. 'I have realised how little I now need to be happy', says Ollivier. Fewer clothes, slower pace of life, beautiful surroundings and time to care for my animals. Ollivier and his sister have built two more villas across from Dar al Hossoun, each with a rescue dog. 'I can't resist them', he says. 'They are totally wonderful, and it wouldn't be home without them'.